IMAGES
of America

TEANECK

To Gary –

Here's to Teaneck!

[signature]

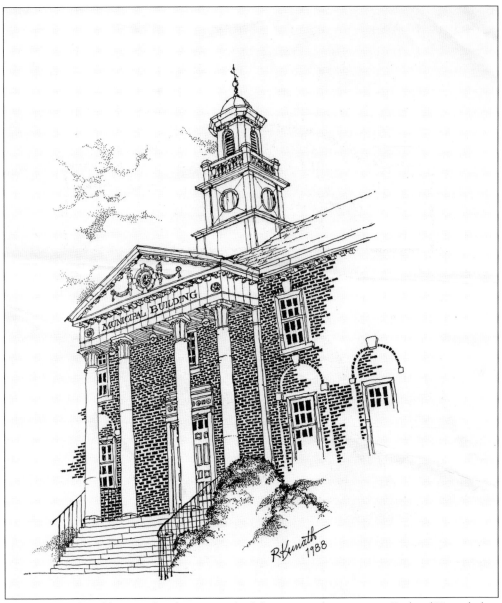

The Municipal Building, rendered in pen-and-ink by artist and sign painter Richard Kunath, has served Teaneck for nearly a century. (Courtesy of Cecilia Kunath.)

ON THE COVER: The Gothic-style structure of Teaneck High School is the backdrop for beloved English teacher William Moore's open-air class. (Photograph by Emmett Francois; courtesy of the Teaneck Public Library.)

IMAGES
of America

TEANECK

Jay Levin

ARCADIA
PUBLISHING

Published by Arcadia Publishing
Charleston, South Carolina

Printed in the United States of America

Library of Congress Control Number: 2019946583

For all general information, please contact Arcadia Publishing:
Telephone 843-853-2070
Fax 843-853-0044
E-mail sales@arcadiapublishing.com
For customer service and orders:
Toll-Free 1-888-313-2665

Visit us on the Internet at www.arcadiapublishing.com

This book is dedicated to lifelong Teaneck resident and history enthusiast Bill Berdan, who passed away on January 4, 2019. Some of the vintage postcards he collected grace these pages.

CONTENTS

ACKNOWLEDGMENTS

Images of America: *Teaneck* was made possible through the support of the Teaneck Historical Society, under the leadership of president Robert Montgomery and secretary Jacqueline Kates, and the Teaneck Public Library, under the leadership of director Allen McGinley. Special thanks to head of reference Weilee Liu for granting me unlimited access to the library's archives and scanning the photographs I selected.

Alice Berdan, a collector of postcards with her late brother, Bill Berdan, handed me her binder and said, "Use what you want." Thank you, Alice.

Julie Greller and Ray Turkin offered valuable technical support, and the present-day photography in these pages is by Ray. I am indebted to them.

It took a township, not a village, for this book to come together. The following people provided photographs, led me to others who had photographs, and assisted in other ways: Judith Distler, Howard Rose, Theodora Lacey, Shahanaz Arjumand, Larry Bauer, Cecilia Kunath, Lorraine Peter, Patricia O'Brien Libutti, Mimi Bookstaver, Erika Gottfried, Paul Ostrow, Joel Nizin, Kathleen Wicklund, Bill Hall, Rosanne Ponchick, Abbe Rosner, Elaine O'Reilly, Carl Mellone, Paul Cohen, Jennifer Lee, Judith Sigel Fox, David Fox, Michael Fedida, David Teichman, William F. "Bill" Julian III, Ken DeVries, Rebecca Maxon, Barbara Bermudez, Pedro Valdes, Rev. Herman Kinzler, Mary Jane Leenstra, Mark Siegler, Susan Edelman, Joan Verdon, and Daniel Sforza.

INTRODUCTION

There is just one Teaneck. The suburb at the crossroads of highways in bustling northern New Jersey is the only place on earth by that name.

Because Teaneck was originally inhabited by the Lenni-Lenape, the name might have descended from *tekene* and *nek*, Indian words meaning "place where there are woods." Or it could be from the Dutch settlers, beginning with Sarah Kiersted, who was granted a swath of land between Overpeck Creek and the Hackensack River from Chief Oratam in appreciation for her services as an interpreter. *Tiene neck,* meaning "neck of land with willows," is a possibility.

So, which is it? No less an authority than Mildred Taylor threw in the towel.

"No one is sure how Teaneck got its name," Taylor wrote in *The History of Teaneck,* "but one thing is certain—it had nothing to do with tea."

Like many New Jersey towns, Teaneck boasts a Revolutionary War pedigree. George Washington and his troops slogged through in retreat from Fort Lee. Four years later, Washington's men returned to keep an eye on British-held New York City. That encampment is commemorated by a historical marker at the intersection of Cedar Lane and Teaneck Road.

The 19th-century dawned with agricultural Teaneck part of Hackensack Township, in Bergen County. By the 1830s, there was a school; by the 1850s, a school district; and by the 1860s, a railroad to carry riders to Jersey City, where they could ferry across the Hudson River to New York City. The train allowed urban dwellers to venture into the New Jersey countryside, and a young lawyer named William Walter Phelps did just that. In 1865, he bought a getaway in what is now the heart of Teaneck. Before long, he relocated permanently to his New Jersey farm, entered politics, and set about to transform his lovely and sparsely settled surroundings.

He greatly expanded his landholdings and meticulously planted hundreds of thousands of trees. He widened and graded the rutted thoroughfare that would become the town's main drag, Cedar Lane. He enlarged his farmhouse again and again, making it a showplace. When it burned down, he moved his family to another impressive house across the way.

Most importantly, William Walter Phelps laid the groundwork for the Teaneck we know today.

In 1922, three decades after his death and Teaneck's incorporation as a township, the vast Phelps estate was opened to residential development. Thus began a boom fueled by the construction of a giant span to New York City. When it opened in 1931, the George Washington Bridge made it possible to drive from Teaneck to the island of Manhattan in under 15 minutes.

Neighborhoods sprouted, and three elementary schools, a high school, a hospital, a town hall, and a public library all opened during the decade of the 1920s. Even the Great Depression failed to stall Treaneck's progress. Managing this growth were public servants distinguished by skill and dedication, such as township manager Paul A. Volcker. Teaneck's reputation as a community on the move was burnished four years after World War II when the Army chose it as America's "model" town, a place where democracy works. A photographic exhibit of life in Teaneck, New Jersey, population 33,000, was shown in Japan and other occupied lands. Teaneck could not have been more proud.

In one sense, the town was hardly a model—its citizenry was predominantly white and Christian, and some wanted to keep it that way. But change was at hand. The demographic shifts that shaped America's suburbs in the 1950s swept over Teaneck. Jews, and then African Americans, began arriving in greater numbers, the latter settling mostly in the township's northeast section. Abetted by real estate agents, some fearful white homeowners in northeast Teaneck sold off to black families. As a consequence, the neighborhood elementary schools had grown worrisomely segregated.

What happened next put the model town in the history books. To address the racial imbalance, a diverse coalition of Teaneck residents and clergy, led by a Jewish mayor, pushed for the integration of the school system through busing. The plan was instituted in 1964 by the board of education and promptly affirmed by voters. No other US community had ever before integrated its schools voluntarily.

Teaneck faced its share of challenges in the ensuing half-century, notably the 1990 fatal police shooting of a black teenager by a white police officer. Suddenly, a town known for tolerance was shaken by unrest. Healing took time and was achieved through soul-searching—a process of community meetings to talk about racial divisions—and the introduction of grassroots community policing. From tragedy, lessons were learned.

Today, Teaneck is an ethnically and religiously diverse township of 41,000; it is a place that in the 21st century's second decade was led by Orthodox Jewish, African American, and Muslim mayors. As in the 1920s, construction is visible; but now, it is of luxury apartments. Travelers are filling the rooms of a new hotel tower. For the world's only Teaneck, the future is bright.

One

BIRTH OF A TOWNSHIP

*The new Township of Teaneck has been created by an act of legislature. Assemblyman Zabriskie
put the bill through the Assembly Monday evening, Senator Winston had it promptly passed by
the Senate on Tuesday morning, and Gov. Werts signed it at once. This will decrease the area
and population of "The Greater Englewood," but it will be more satisfactory to the people of the
new township than a borough government. They will . . . have full control of their affairs.*

—The *Hackensack Republican*, February 21, 1895

Near the end of the 19th century, Teaneck had a population in the hundreds and consisted of
farmland and the estate of William Walter Phelps. No one was more instrumental to civic affairs
than Phelps, a lawyer and politician and the area's largest landowner and taxpayer. He also was a
proponent of Teaneck establishing a political identity independent of Englewood and Ridgefield
townships, of which it was then part. Phelps did not live to see that day. He died in 1894, eight
months before the Township of Teaneck was incorporated.

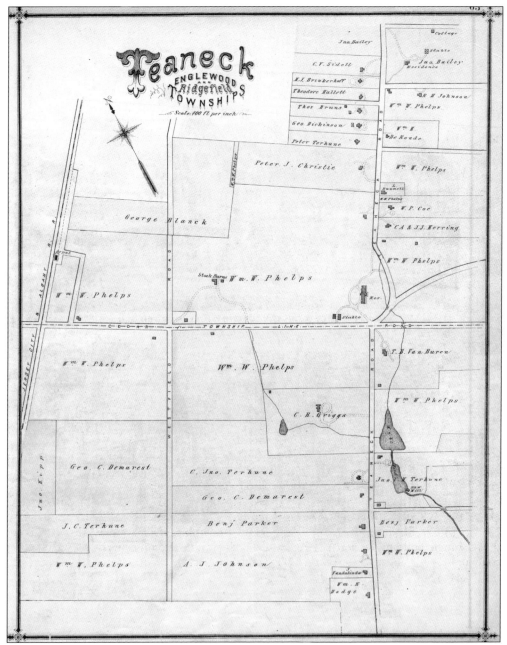

This late-19th-century map shows Teaneck as part of both Englewood and Ridgefield townships. Cedar Township Line would become Cedar Lane, Westfield Road would become Queen Anne Road, and Teaneck Road would retain that name. The map divides the rural community into holdings by landowner. One name appears more than others: Wm. W. Phelps, or William Walter Phelps. (Courtesy of the Teaneck Public Library.)

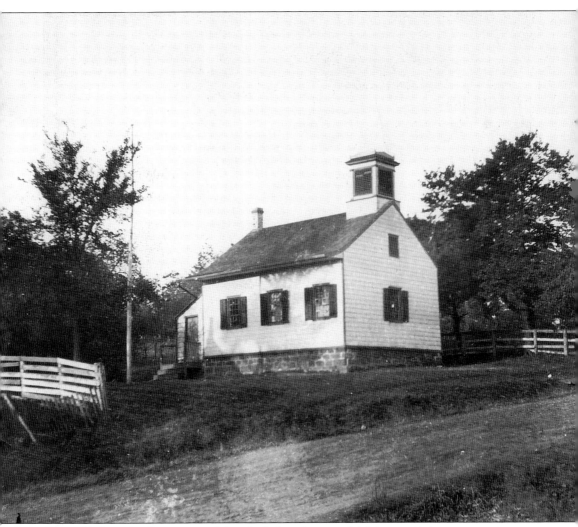

Teaneck's first school, constructed decades before the township's incorporation, was a one-room, shake-shingle building on Fort Lee Road. It served children from Teaneck and surrounding communities. (Courtesy of the Teaneck Public Library.)

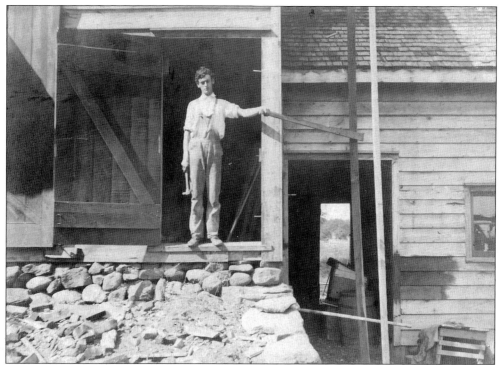

Above, John V.H. Terhune operated this sawmill and gristmill in the Fycke Woods in the late 19th century, when farming was prevalent in Teaneck. The location is near the present site of Thomas Jefferson Middle School, on Teaneck Road at Johnson Avenue. Teaneck Road at the turn of the 20th century, seen below, was a pastoral route lined with trees that burst with fragrant blossoms in the spring. (Both, courtesy of the Teaneck Public Library.)

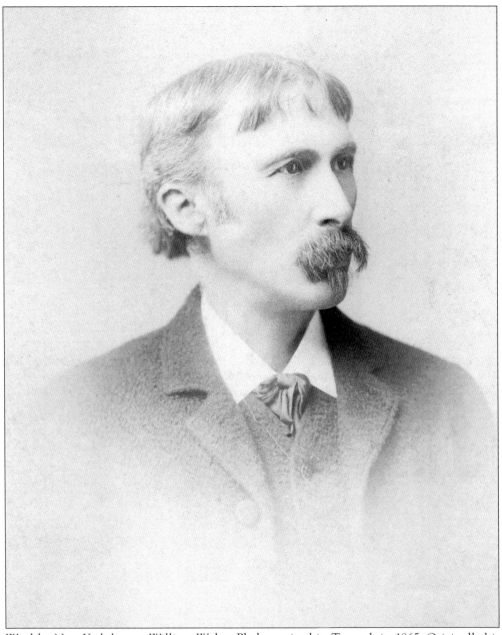

Wealthy New York lawyer William Walter Phelps arrived in Teaneck in 1865. Originally his summer home, Teaneck became Phelps's personal and political base. He served four terms in the US House of Representatives in the 1870s and 1880s and also as a foreign envoy and ambassador. But rural Teaneck knew Phelps best as the painstaking owner of more than 2,000 acres of land, on which he indulged his hobby of arboriculture. He planted some 600,000 trees—Norway spruces, American elms, white pines, Scotch pines, lindens, arborvitae, willows, catalpas, and more. "Mr. Phelps personally planned an elaborate scheme of decorative and protective planting that promised the most effective result artistically and gave the greatest benefit of shade to the driveways and bridle-paths," wrote his biographer, Hugh M. Herrick. In so doing, Phelps created the verdant canvas that would become the township of Teaneck. (Courtesy of the Berdan collection.)

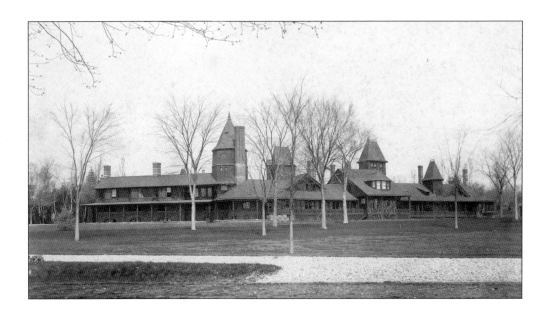

Above, William Walter Phelps and his family resided in this magnificent mansion known as the Grange, located on the current site of the Municipal Building. Phelps kept building additions until the home, originally a Dutch farmhouse, measured 350 feet wide. On April 1, 1888, a gas explosion in the gallery housing Phelps's art collection sparked a massive fire. No one was injured —Phelps himself was in the nation's capital—but the mansion was destroyed. Its ruins, below, stood for 37 years, an eerie Teaneck landmark. (Both, courtesy of the Teaneck Public Library.)

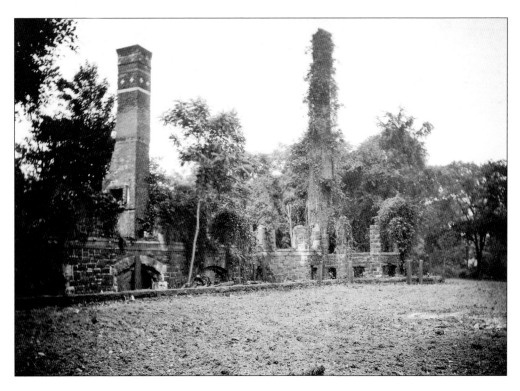

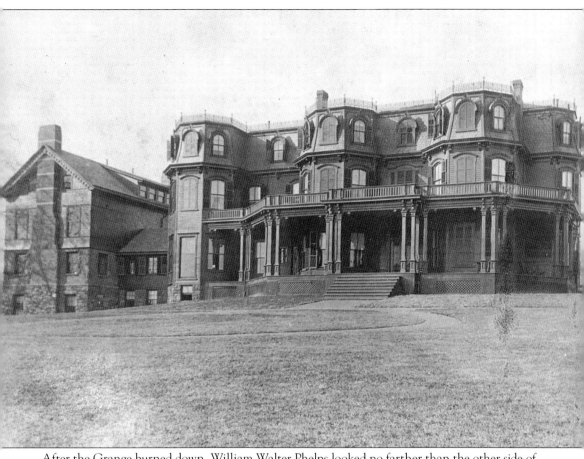

After the Grange burned down, William Walter Phelps looked no farther than the other side of Cedar Lane and acquired the property and home of cotton broker C.R. Griggs. Phelps moved his family there, and that is where he died on June 17, 1894, at age 54. Holy Name Medical Center stands on the site today. (Courtesy of Teaneck Public Library.)

Above, William DeGraw is shown third from right with his family on the lawn of their rambling home at Teaneck Road and DeGraw Avenue, and below, DeGraw stood with his daughter at the new trolley station nearby. DeGraw, a prosperous farmer and township official, was instrumental in bringing the trolley to Teaneck. At the ceremony in 1899 hailing the start of service, he was partially run over by a trolley car, and the injury led to his death two years later. (Both, courtesy of the Teaneck Public Library.)

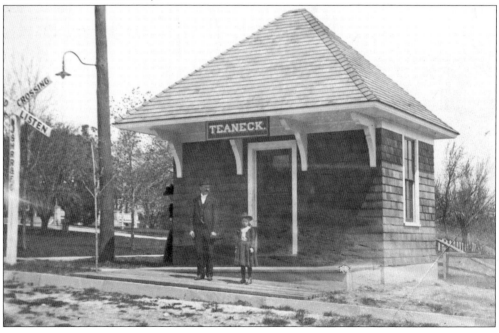

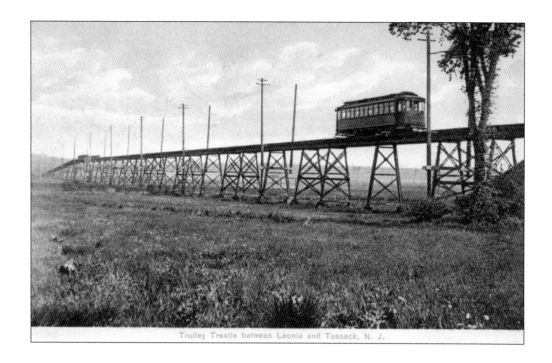

Trolley Trestle between Leonia and Teaneck, N. J.

A trolley, above, rides over the trestle between Teaneck and Leonia. The postcard below shows trolley tracks embedded in DeGraw Avenue. The line stretched east to Edgewater, where commuters could catch a Hudson River ferry to Manhattan, and west to Hackensack and Paterson. Service ended on August 5, 1938, with the Public Service Corporation of New Jersey replacing the trolleys with buses. (Both, courtesy of the Berdan collection.)

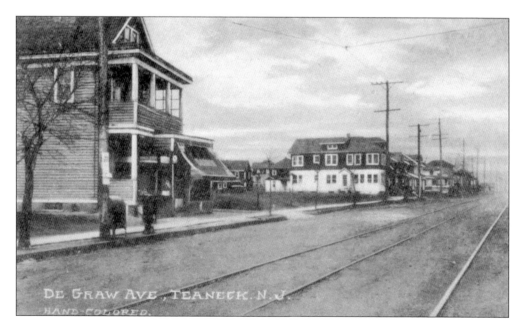

DE GRAW AVE., TEANECK, N. J.
HAND-COLORED.

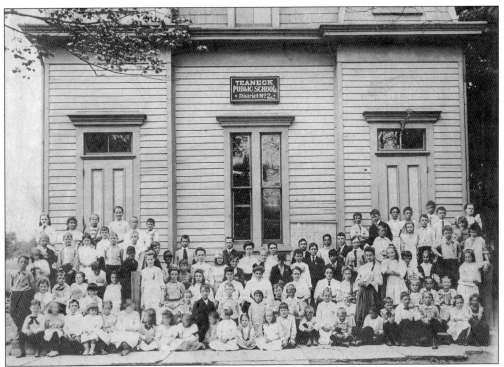

Above, students and faculty of School No. 2, at Teaneck Road and Forest Avenue, gather for a picture around the turn of the 20th century. The c. 1869 structure saw double duty as town hall—government offices occupied the second floor after Teaneck's incorporation. In 1906, the building was replaced on the same spot by a new redbrick school and was carted off to Church Street. Below, it continued as the seat of government until 1926, when the current Municipal Building was completed. (Above, courtesy of the Teaneck Public Library; below, courtesy of the Berdan collection.)

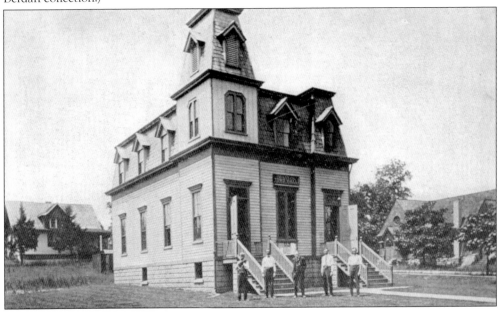

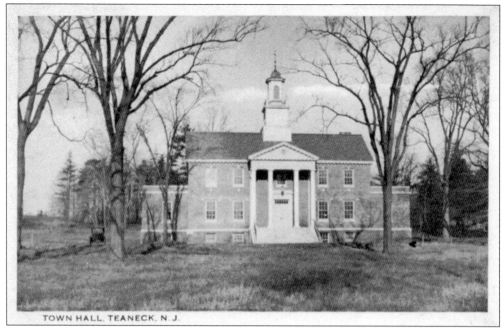

TOWN HALL, TEANECK, N.J.

The Teaneck Municipal Building, seen shortly after its 1926 opening, was constructed on the site of the Phelps mansion ruins, at Cedar Lane and Teaneck Road. (Courtesy of the Berdan collection.)

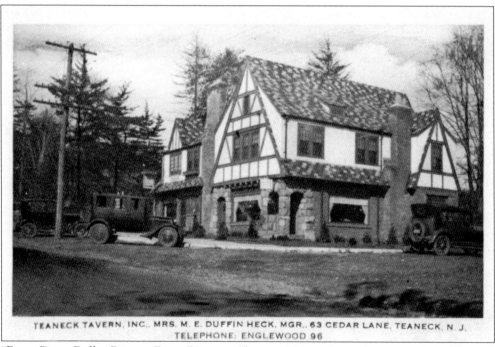

TEANECK TAVERN, INC., MRS. M. E. DUFFIN HECK, MGR., 63 CEDAR LANE, TEANECK, N. J.
TELEPHONE: ENGLEWOOD 96

"Every Day a Dollar Dinner, Every Dinner a Pleasant Memory" was the motto of the Teaneck Tavern on Cedar Lane. Its 50¢ businessman's lunch was hamburger steak and fried onions and likely was popular with township leaders because the Municipal Building was steps away. The Tudor-style building today houses Amarone Ristorante. (Courtesy of the Berdan collection.)

The Anderson Street Bridge opened in 1898 over the Hackensack River, linking Cedar Lane in Teaneck and Anderson Street in Hackensack. In this pretty scene, a horse-drawn buggy crosses into Hackensack. As Teaneck and Hackensack grew into bustling communities, the two-lane, iron girder bridge became obsolete. It was replaced by a span carrying four lanes of traffic in 1970. (Courtesy of the Berdan collection.)

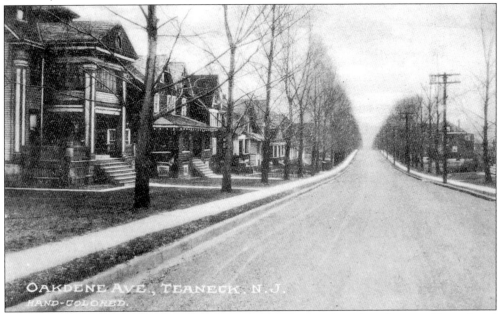

This postcard shows Oakdene Avenue in the early 20th century. Stretching between Teaneck and Queen Anne Roads in southern Teaneck, Oakdene Avenue boasts some of the township's oldest homes and a variety of architectural styles. The beginning of trolley service along nearby DeGraw Avenue spurred development in this part of town. (Courtesy of the Teaneck Public Library.)

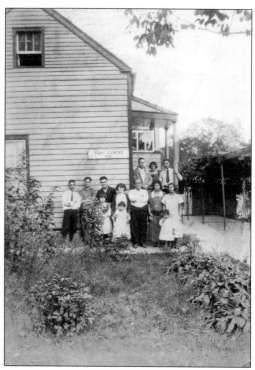

In the c. 1922 photograph at right, Tony Cancro, arms folded, is surrounded by his large family in front of their home at 635 Teaneck Road, at Fycke Lane. Cancro moved to Teaneck from New York City, where he worked in the carting business. He eventually replaced the house with a filling station, seen below around 1930, and relocated the family to an apartment house he built next door, partially visible at the far left. The filling station is today an automotive repair center, and the apartments now make up a professional building. (Both, courtesy of the Cancro family.)

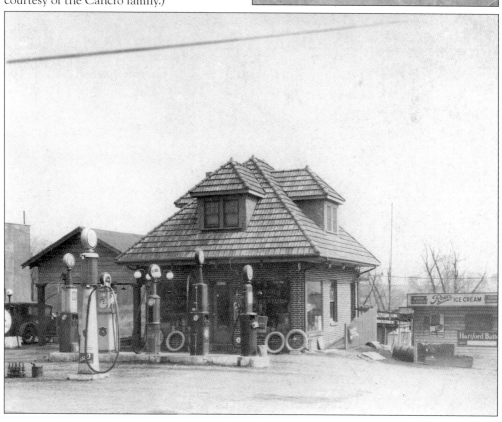

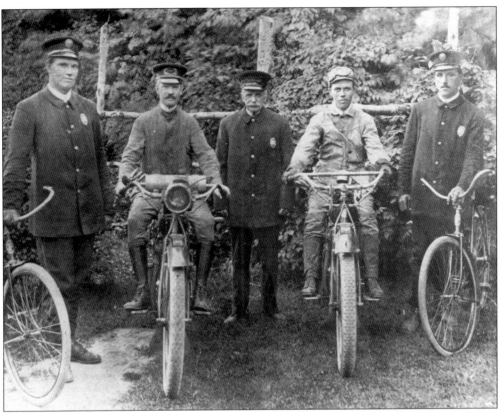

Teaneck was originally patrolled by part-time constables, but the shooting death of a reveler during the 1913 Fourth of July celebration heightened calls for a full-time police force. The township committee established the department the following year. Above, keeping the peace around 1916 are, from left to right, William Luthans, Chief Edward Murphy, J. Brinkerhoff, Jesson Witham, and Joseph Bublitz. The photograph below shows a larger force in 1925 but still on two wheels. (Both, courtesy of the Teaneck Public Library.)

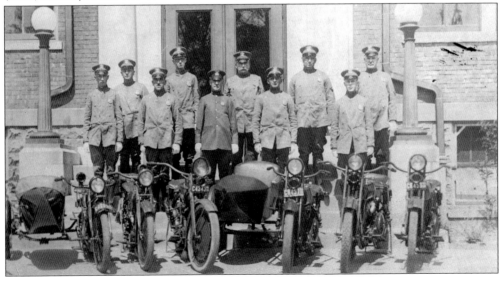

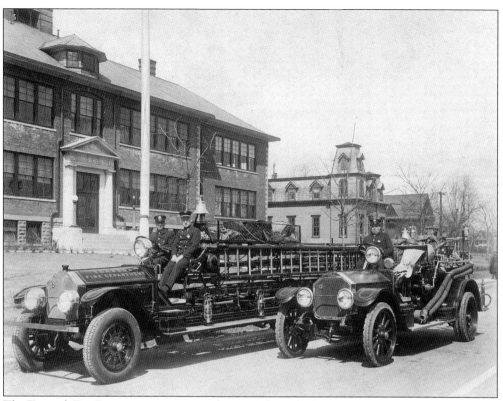

The Teaneck Fire Department was created in 1915 through the consolidation of four of the town's five volunteer independent fire companies. In photographs from the 1920s, fire apparatus stopped in front of School No. 2, above, and the men of the department lined up outside headquarters at 1217 Teaneck Road, below. The department today numbers 90 full-time uniformed members; in 2018, Teaneck firefighters responded to 3,889 calls. (Both, courtesy of the Teaneck Public Library.)

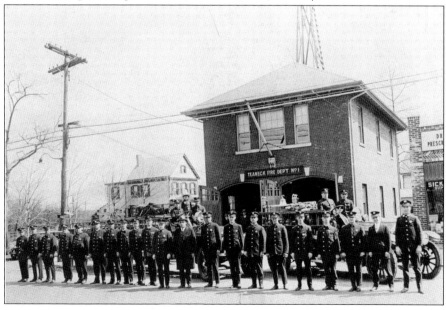

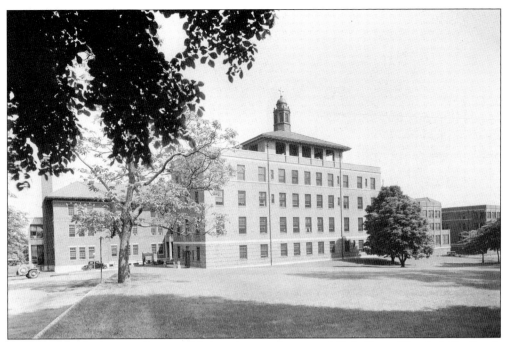

The photograph above and postcard below show early views of Holy Name Hospital. Dr. Frank McCormack and Dr. George Pitkin saw the need to serve the community's sick and indigent and partnered with Mother General Agatha Brown of the Sisters of St. Joseph of Peace, who purchased the home of the late William Walter Phelps. A 115-bed hospital opened on October 4, 1925. The first surgical patient was Marion Wissler, of Bergenfield, who had appendicitis. Several expansions and a name change later, the 361-bed Holy Name Medical Center is still sponsored by the Sisters of St. Joseph of Peace. (Above, courtesy of Holy Name Medical Center; below, courtesy of the Berdan collection.)

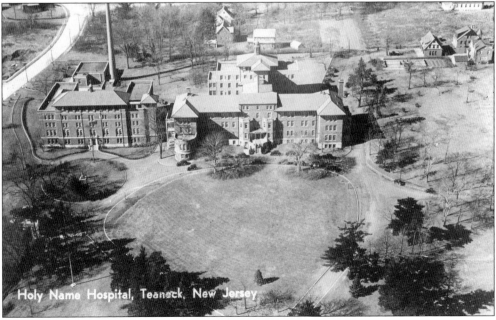

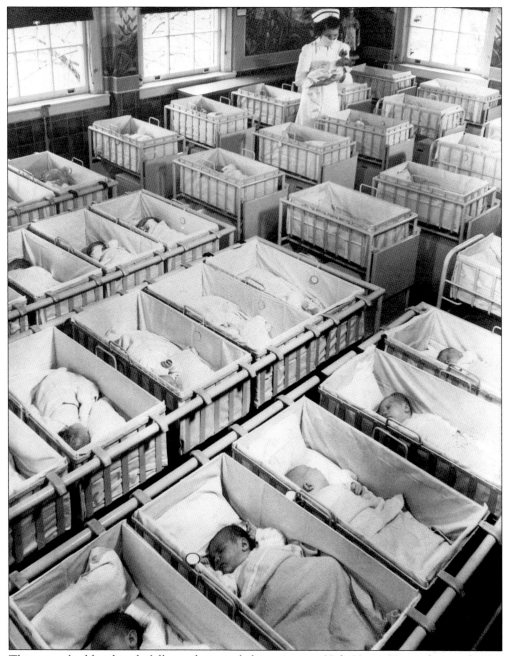

This nurse had her hands full—and a crowded nursery—at Holy Name Hospital around 1930. Tens of thousands have come into the world at Teaneck's hospital, which logs an average of 1,300 births a year. When a baby is born, the lullaby "Hush Little Baby" chimes over the public address system. (Courtesy of Holy Name Medical Center.)

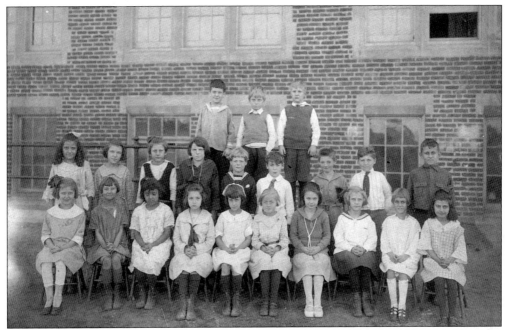

School No. 3's first graders posed for their class portrait in 1920. What would become Emerson School, at North Street and Elm Avenue, closed in 1984 during a district-wide reorganization. The building now houses a private school. (Courtesy of the Teaneck Public Library.)

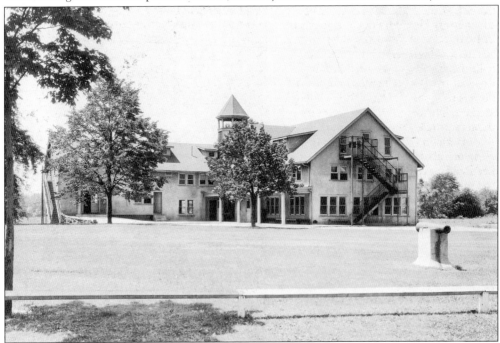

The Roosevelt Military Academy, in the West Englewood section, molded "healthy and happy" boys in the 1920s and 1930s. Students received "an excellent education and a thorough training in those fundamentals which make sterling character and good citizenship," the school's newspaper advertisement stated. (Courtesy of the Teaneck Public Library.)

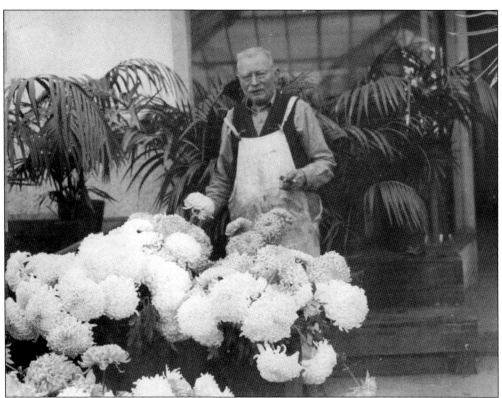

The nursery Herman Encke established in 1906 is one of Teaneck's oldest businesses. The German immigrant built three greenhouses on Fort Lee Road, at the Bogota border, and raised flowers to sell in the New York wholesale markets. The enterprise expanded into the retail trade. These photographs show Herman Encke posing with his blossoms, above, and his shop on Fort Lee Road, at right. Working with the soil suited Encke; he lived to 93. Encke Flowers and Gifts is now located around the corner on Queen Anne Road. (Both, courtesy of Jennifer Lee.)

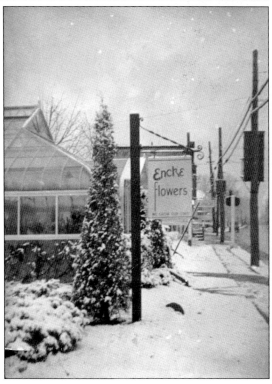

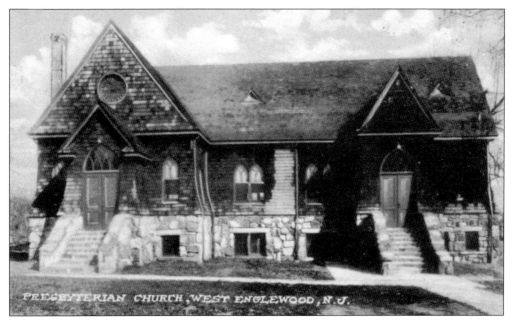

Presbyterian Church of Teaneck was the township's first church. Organized on May 24, 1906, it was an outgrowth of the nonsectarian Washington Avenue Union Sunday School Association. The church is shown here after the first expansion of the c. 1894 building, on Teaneck Road at Church Street, that housed the Sunday School Association. The current church building on the site, distinguished by its columned portico, was dedicated in 1956. (Courtesy of the Berdan collection.)

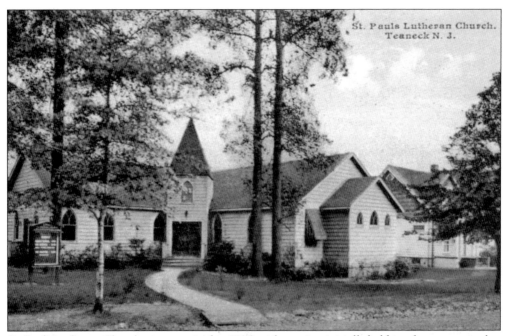

St. Paul's Lutheran Church was organized in 1925, with services initially held in a home acquired as a parsonage. The first church building, seen here, was constructed in 1928 on Church Street. It was replaced by a larger house of worship and school in 1953. (Courtesy of the Teaneck Public Library.)

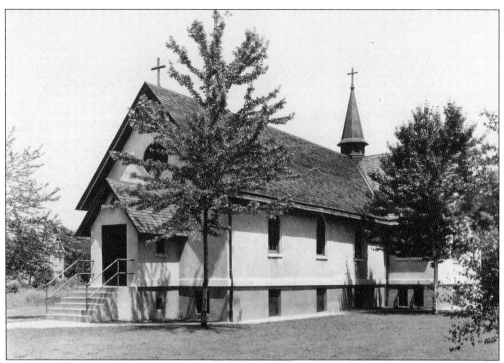

Irish immigrant Anastasia Kelly believed Teaneck's Catholics should not have to go to Hackensack or Englewood to worship. At age 80, she secured a parcel at the corner of Teaneck Road and Robinson Street for construction of a stucco chapel, above. It was dedicated on August 2, 1908, as Teaneck's second church. Below, a new St. Anastasia Church, designed in the Late Romanesque Revival style, was built a stone's throw from the original chapel in 1932. (Both, courtesy of the Teaneck Public Library.)

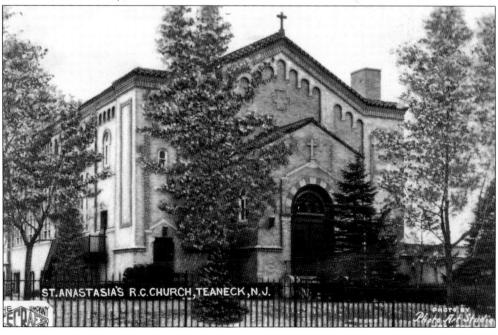

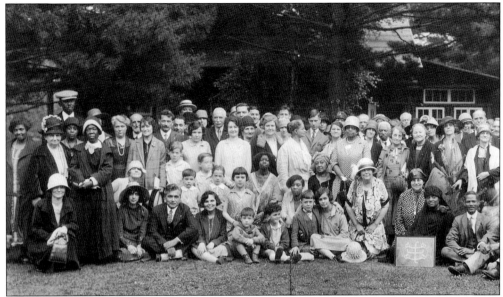

Roy Wilhelm, a New York businessman and prominent early adherent of the Bahá'í Faith, built a home in Teaneck's countrified West Englewood section in 1908. On June 29, 1912, he played host to 'Abdu'l-Baha, son of the founder of the Bahá'í Faith, at a unity feast attended by American Bahá'ís from the region and beyond. The June picnic is an annual event at the Bahá'í property in Teaneck. The photograph above, taken by Wilhelm at the 1926 picnic, shows a group that was astonishingly diverse for the time. Seated on the ground at the far right is Louis Gregory, one of only 50 people in the more than 150-year history of the Bahá'í Faith to hold the honorary title of "hand of the cause of God." The centerpiece of the evergreen-studded property is the iconic Evergreen Cabin, as seen in the postcard below. (Above, courtesy of Joel Nizin; below, courtesy of the Teaneck Public Library.)

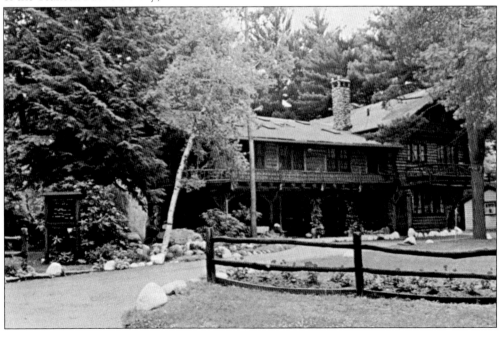

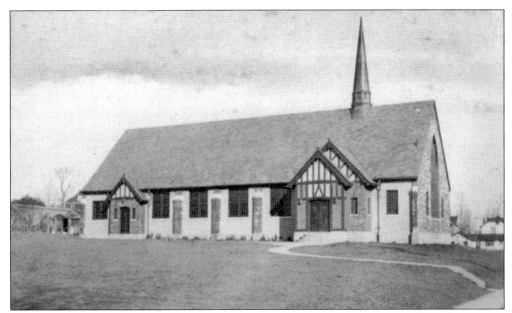

What is now Teaneck United Methodist Church has stood on DeGraw Avenue at Hickory Street since 1924. The congregation traces its roots to a nondenominational union formed in 1901 for the purpose of holding Sunday school classes. A vote to affiliate with Methodism occurred in 1915, and the drive to purchase property for construction of a church building began soon after. (Courtesy of the Berdan collection.)

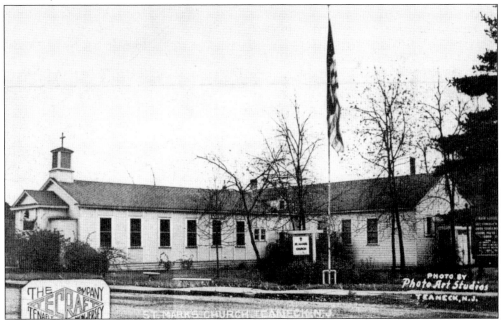

St. Mark's Episcopal Church grew out of the Sunday school classes Grace and Floyd Chadwick held in their Cedar Lane home. To accommodate the burgeoning parish, a lot at Grange and Chadwick Roads was purchased from the Phelps estate and a prefabricated World War I field chapel erected. The first service was held on Christmas morning in 1925. The original building pictured here was replaced in 1959 by the current parish hall. (Courtesy of the Berdan collection.)

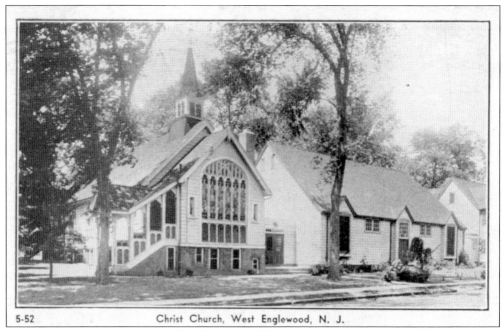

Christ Church, West Englewood, N. J.

Two years after residents of the West Englewood Park section began hosting religious services in their homes, Christ Church, an Episcopal congregation, was dedicated at Rugby Road and Rutland Avenue. The original c. 1915 building is seen here; the current Christ Episcopal Church was completed in 1953 several blocks away, on Warwick Avenue. (Courtesy of the Teaneck Public Library.)

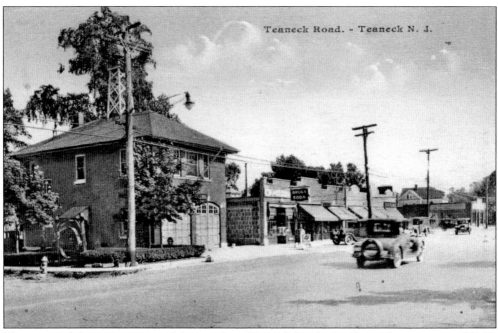

Teaneck Road. - Teaneck N. J.

This postcard shows a commercial district along Teaneck Road, near Forest Avenue, around 1930. The fire headquarters is at left. (Courtesy of the Berdan collection.)

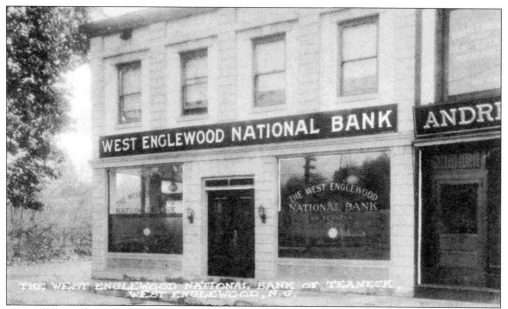

One of Teaneck's earliest financial institutions, the West Englewood National Bank was organized in 1923 with an initial capital of $50,000. The bank touted its location near the West Englewood train station. (Courtesy of the Teaneck Public Library.)

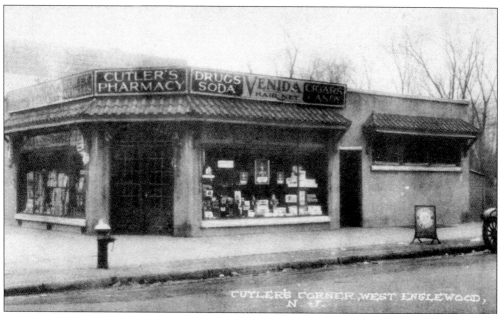

Cutler's Pharmacy, near the West Englewood train station, served the community from the 1920s through the 1980s. (Courtesy of the Berdan collection.)

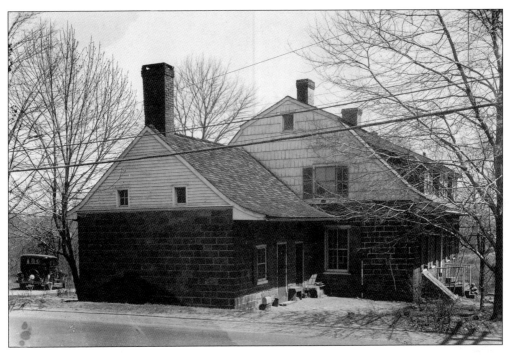

The Brinkerhoff-Demarest House, pictured above around 1930, is Teaneck's oldest home. The sandstone-and-clapboard Teaneck Road residence was constructed in 1735 by Hendricks Brinkerhoff. It was in the hands of the Brinkerhoff family until 1829, then owned by generations of the Demarest family. The house has sprouted a satellite dish, as seen in the 2019 photograph below. (Above, courtesy of the Teaneck Public Library; below, photograph by Ray Turkin.)

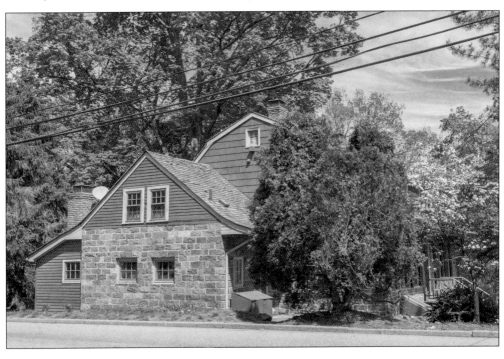

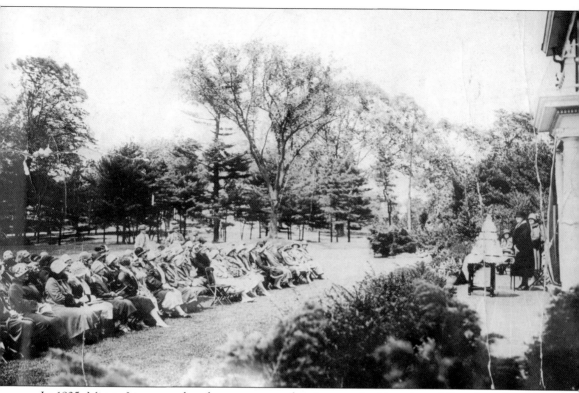

In 1925, Minna Lippman placed a newspaper advertisement inviting the public to her elegant Monterey Avenue home "for the purpose of forming a woman's club as a medium for sociability and the dissemination of culture, the exercise of philanthropy, and participation in civic affairs." Some 135 women turned out for the May 5 meeting on Lippman's lawn, and thus, the Woman's Club of Teaneck was organized. Minna and her husband, Bernard, were among the township's first Jewish residents. (Courtesy of the Teaneck Public Library.)

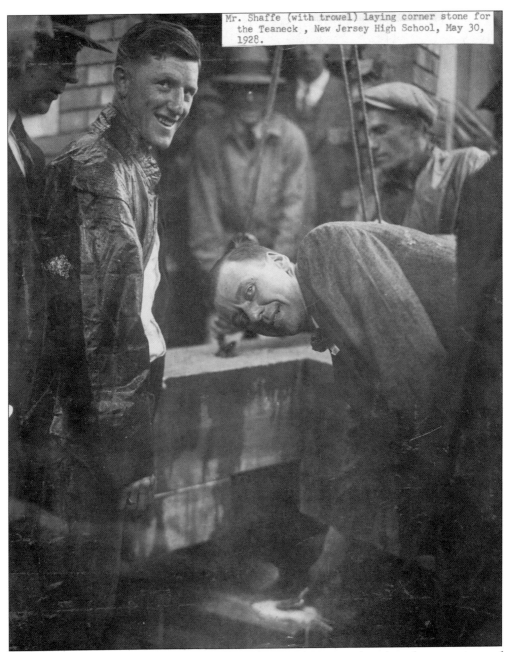

Mr. Shaffe (with trowel) laying corner stone for the Teaneck , New Jersey High School, May 30, 1928.

Board of education president Chris D. Sheffe, with a trowel, cemented in place the cornerstone of Teaneck's new high school on May 30, 1928. A box placed in the cornerstone contained a Bible, a list of school board members, coins representing township organizations, and an American flag. A year earlier, Teaneck voters overwhelmingly approved spending $726,000 for the construction of a high school on a 13-acre campus so older students would not have to attend classes in Hackensack, Bogota, and other towns. Teaneck High School was dedicated on January 31, 1929. During that ceremony, Christian Gloeckler, chairman of the township committee, prophetically declared, "The opening of this building is the biggest event in the history of Teaneck, and I doubt not that at some future day, a university will be located in Teaneck." (Courtesy of the Teaneck Public Library.)

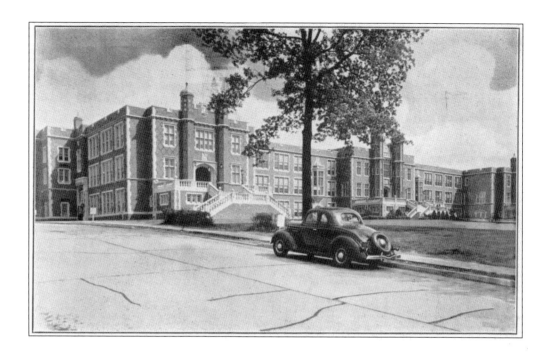

These 1930s postcards show Teaneck High School's Elizabeth Avenue side, above, and students playing field hockey on the lawn, below. The handsome Gothic structure is known as "the Castle on the Hill." (Both, courtesy of the Berdan collection.)

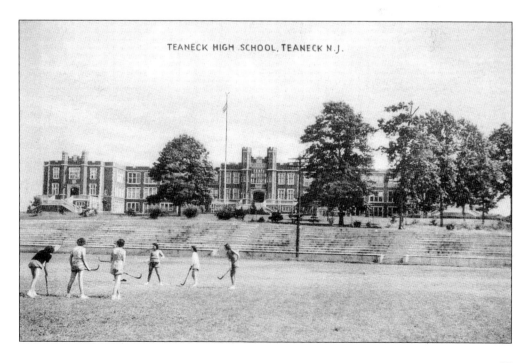

TEANECK HIGH SCHOOL, TEANECK N.J.

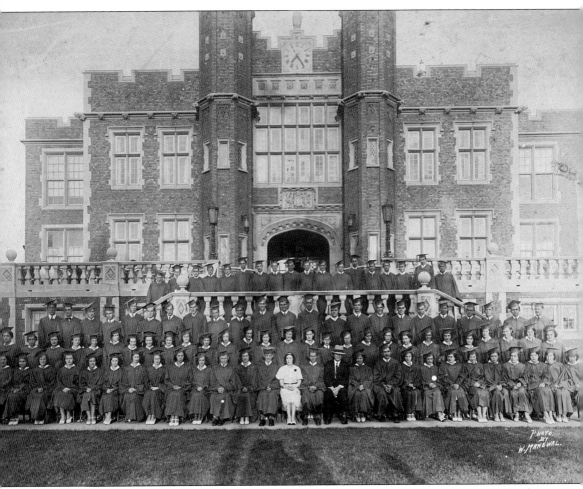

Dressed in gowns and mortarboards, Teaneck High School's second graduating class—the class of 1932—posed in front of the Castle on the Hill. At the commencement, senior class president George Thurlby presented to the school plaques bearing images of George Washington and Abraham Lincoln. Over the following nine decades, prominent graduates have included Paul A. Volcker Jr. (1945), chairman of the Federal Reserve under presidents Ronald Reagan and Jimmy Carter; David Stern (1959), who was commissioner of the National Basketball Association for 30 years; Peter Pace (1963), chairman of the Joint Chiefs of Staff under Pres. George W. Bush; Phoebe Laub (1968), the singer-songwriter known as Phoebe Snow; the film critic Leonard Maltin (1968); and Tamba Hali (2002), who played linebacker for the Kansas City Chiefs. (Courtesy of Howard Rose.)

Two

BUILDING BLOCKS

With plans now being completed for the development of the Phelps estate, Teaneck will in the next ten years be counted among the four largest populated townships in Bergen County. The building operations for the next few years will, according to plans now under preparation by the various realty companies, be the greatest undertaking of the kind ever seen in Bergen County before. Not only will the developing of the Phelps estate, which today takes in nearly half of Teaneck and which now is nothing but an immense forest, greatly increase the population of the township, but it will be the connecting link to the five sections of Teaneck.

—The *Bergen Evening Record*, September 15, 1922

Teaneck boomed in the 1920s as the construction of the George Washington Bridge, linking Manhattan and New Jersey, got under way. Sturdy houses rose seemingly overnight, and streets were laid on what had been farmland and pieces of the Phelps estate. Landmarks that stand to this day were dedicated: Holy Name Hospital, in 1925; the Municipal Building, in 1926; the public library, in 1927; and the high school, in 1929.

Importantly, state highway Route 4 across Bergen County was completed in 1932, providing Teaneck residents with a direct route to the new Hudson River span.

With the infrastructure in place, political leaders turned their attention to the inner workings. Under a new nonpartisan form of government, the township council took the crucial step of hiring its first professional municipal manager. Teaneck was on its way.

The Golden Harvest Across the Hudson
Will You Reap YOUR Share?

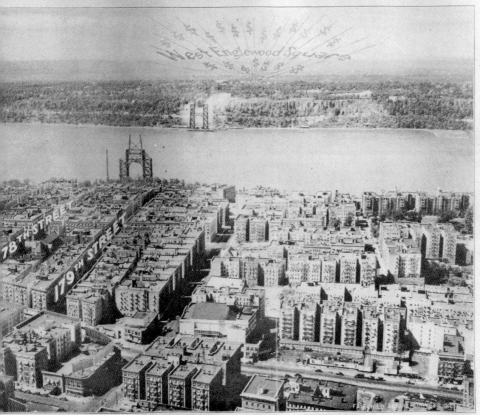

This developer's advertisement for West Englewood Square—"a clean-cut, inviting, modern community that beckons to investor, businessman and merchant!"—is noteworthy for its rendering of the partially built George Washington Bridge. In the foreground, chock-a-block upper Manhattan is contrasted with the wide-open spaces of Bergen County. West Englewood Square was promoted as a shopping, office, and residential district anchored by a train station. Today, the business district is home to kosher food businesses and private schools catering to the Orthodox Jewish community. (Courtesy of the Teaneck Public Library.)

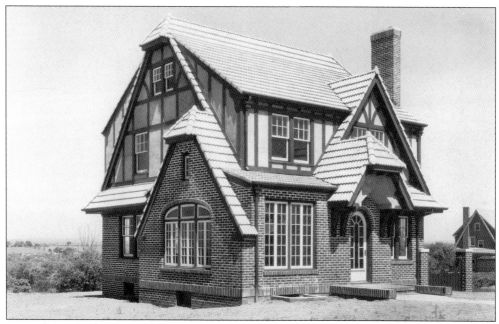

Teaneck farmland gave way to rampant homebuilding in the 1920s. Above, an English-style house on Hudson Road awaited residents in the West Englewood Manor development. "More than fifty sites have been sold in the last two weeks and the demand is unabated," D.S. Levy, president of Hudson West Shore Realty Corporation, told the *New York Times* in May 1927. "Home building activity is apparent everywhere throughout the bridge zone." Below, workmen prepared Hudson Road for pavement and sidewalks. (Both, courtesy of the Teaneck Public Library.)

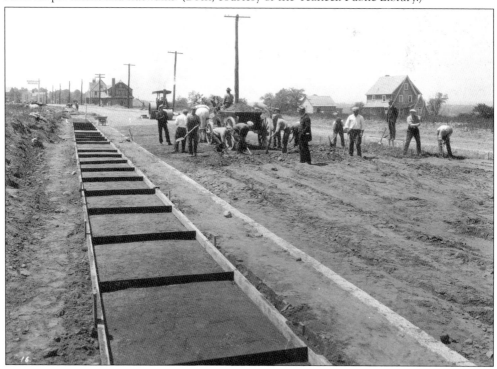

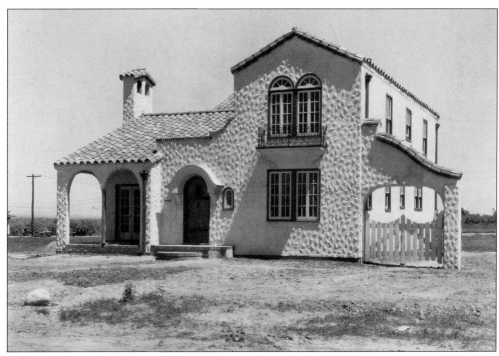

Not every home the Hudson West Shore Realty Corporation built in West Englewood Manor was of the English variety. Above is a Spanish Colonial. The developer's sales office is pictured below. (Both, courtesy of the Teaneck Public Library.)

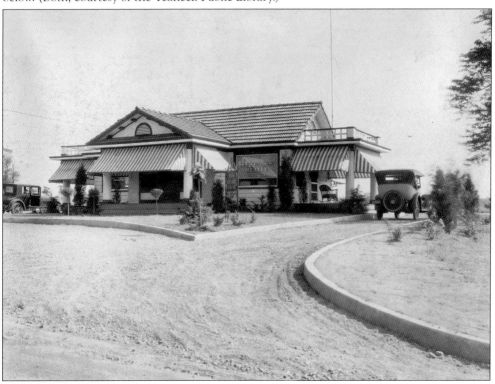

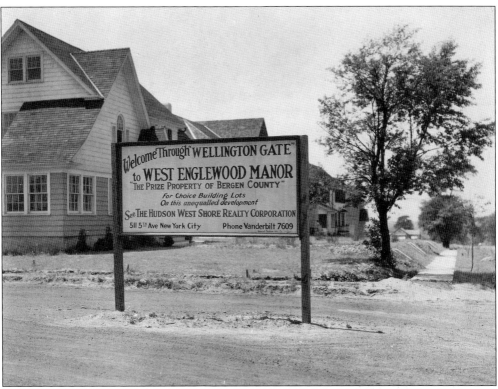

The Hudson West Shore Realty Corporation promoted its building lots in West Englewood Manor. Above, a sign welcomed one and all to the development's Wellington Gate section. Below, Wellington Gate's open spaces would soon sprout a neighborhood. (Both, courtesy of the Teaneck Public Library.)

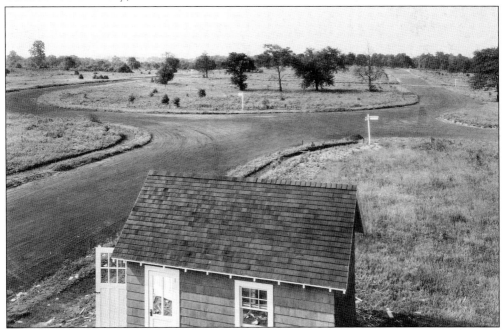

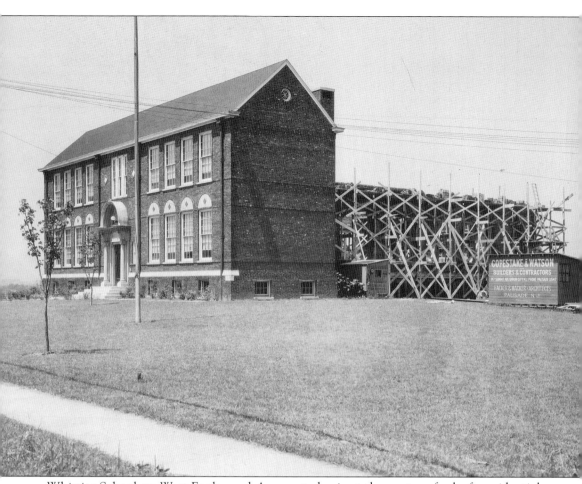

Whittier School on West Englewood Avenue today is at the center of a leafy residential neighborhood. But in the 1920s, the former School No. 4 stood virtually alone. The building opened in 1922; this photograph shows the addition of an auditorium in 1927. (Courtesy of the Teaneck Public Library.)

No public servant left as great an imprint on Teaneck as Paul A. Volcker, here being sketched by artist Aubrey Mills in 1946. The township's first professional manager under the nonpartisan form of government, Volcker served for two decades, straightening township finances and deftly steering Teaneck through the Depression and war years. The strapping civil engineer professionalized emergency services, oversaw the creation of parks, and hired stellar department heads such as recreation superintendent Richard Rodda and health officer Barnet Bookstaver. Volcker and his wife, Alma, raised their family on Longfellow Avenue; son Paul Jr., a 1945 graduate of Teaneck High School, was the Federal Reserve chairman under two presidents. His yearbook photograph is shown below. Teaneck's municipal green is named for the senior Volcker. (Both, courtesy of the Teaneck Public Library.)

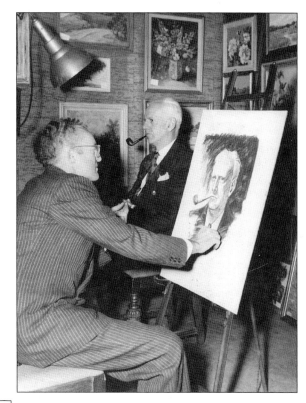

Paul Volcker

Incredible knowledge of politics,
Little "Buddy" measures way above six.
Something about him—none can resist;
He'll be Town Manager friends all insist.

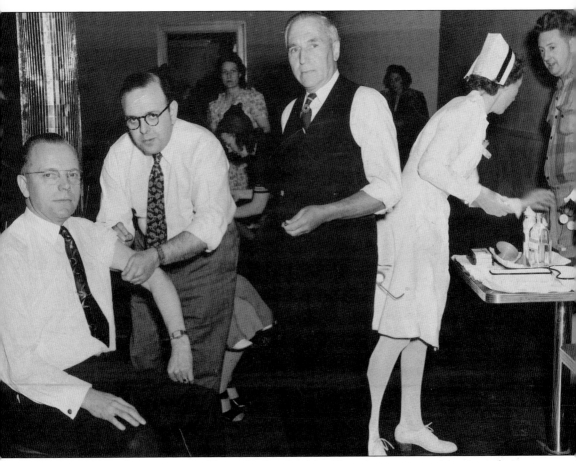

Dr. Barnet Bookstaver, center, Teaneck's first health officer, is seen supervising inoculations during an influenza epidemic. School superintendent Lester Neulen, with his sleeve rolled up, was about to get the needle. The good doctor was a popular figure in Teaneck, serving also as school physician and police and fire department surgeon. Working for $1 a year, Bookstaver saw to it that every schoolchild was inoculated against diphtheria and whooping cough and put into effect myriad regulations aimed at the public good, such as the regular inspection and rating of food stores and a prohibition against smoking in public vehicles. Dedicated to the end, he suffered a fatal heart attack while providing medical services at a 1951 fire. More than 1,800 people turned out for Bookstaver's funeral at the Teaneck Jewish Community Center, of which he was a founder. (Courtesy of the Teaneck Public Library.)

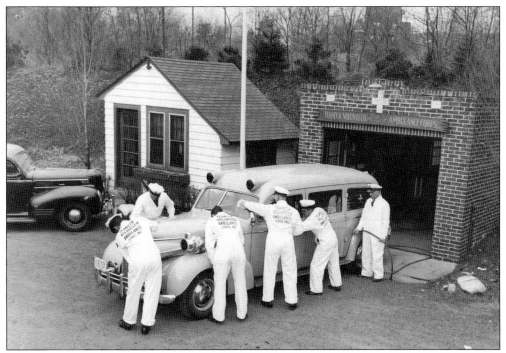

Above, members of the Volunteer Ambulance Corps spruced up their first vehicle, whose purchase in 1939 was made possible through community fundraising. Township dog warden Cornelius Van Dyk spearheaded the formation of the corps. Below, he and Jimmy Thompson, a young corps member, traveled to Ohio to pick up the 1936 LaSalle. (Both, courtesy of the Teaneck Public Library.)

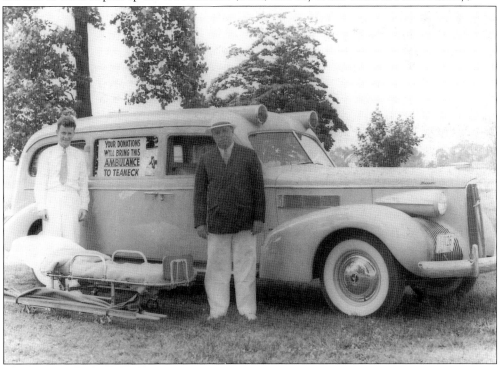

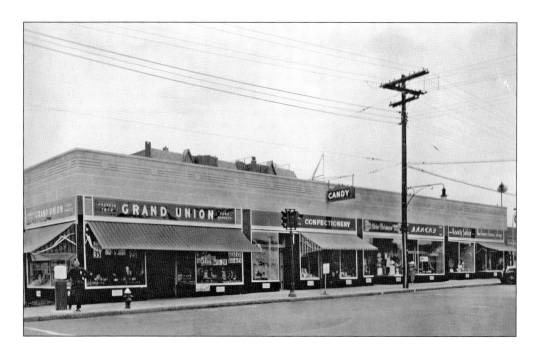

The center of the Cedar Lane business district is at Chestnut Avenue. Above, an officer stood by the police call box outside the Grand Union grocery in 1935. The confectionery next to Grand Union is Bischoff's, and the bakery two doors from Bischoff's is Gratzel's. Below, the street corner is seen in 2019. So much is different, but one will still find Bischoff's. (Above, courtesy of Carl Mellone; below, photograph by Ray Turkin.)

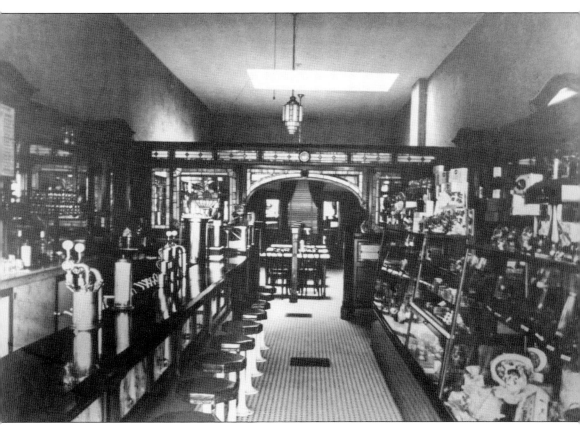

Here is the interior of Bischoff's on Cedar Lane shortly after Albert Bischoff started the business in 1934. The soda fountain is at left, the candy counter is at right, and the dining room is in the rear. The sweet shop, which still makes its own ice cream, celebrated its 85th anniversary in 2019 by accepting credit cards and electronic payments. "It's time to jump into the modern age," said Steven Mather, Albert Bischoff's great-grandson and one of the co-owners. (Courtesy of Bischoff's.)

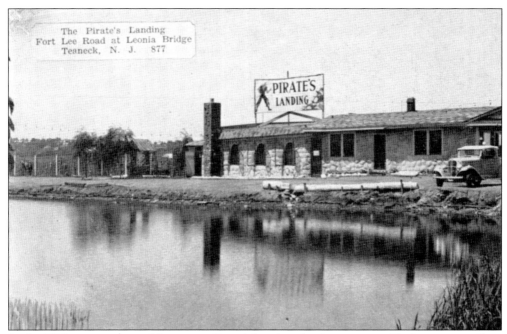

In the 1930s, customers could count on Pirate's Landing for American and Italian cuisine, floor shows, orchestra music, and dancing. The lively roadhouse stood on Fort Lee Road at the bridge spanning Overpeck Creek to Leonia. (Courtesy of the Berdan collection.)

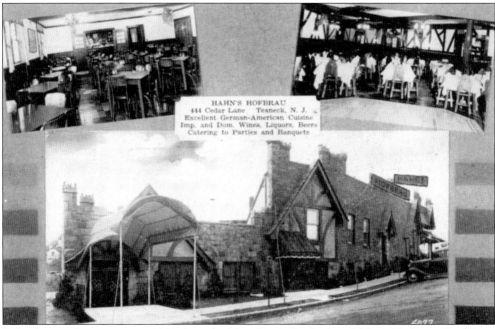

What better place to ring in 1940 than the New Year's Eve bash at Hahn's Hofbrau? For $5 per couple, the Cedar Lane restaurant—"Step into old Bavaria!"—offered a steak dinner, cocktails, dancing, and noisemakers. (Courtesy of the Teaneck Public Library.)

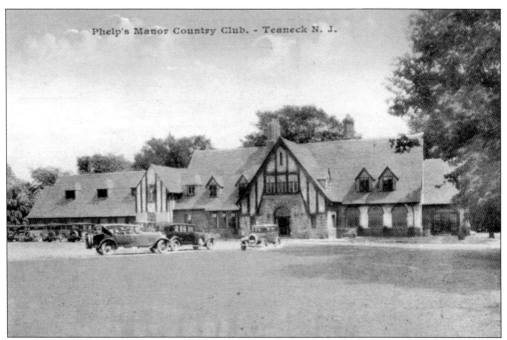

Phelps Manor Country Club was the scene of many a dinner dance and gala, and its 18-hole golf course was championship quality. The golf course, between Route 4 and East Cedar Lane, was rezoned in 1947 to allow for residential development. (Courtesy of the Berdan collection.)

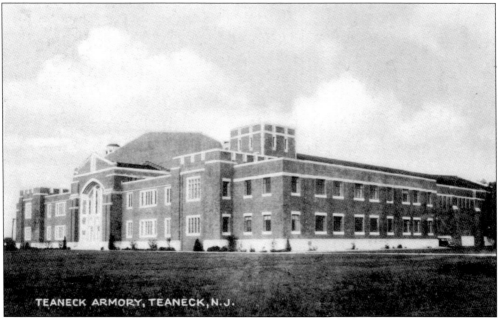

Built in the late 1930s with the help of a federal Public Works Administration grant, the Teaneck Armory has served a variety of roles besides housing the New Jersey National Guard. It has hosted political rallies, circuses, religious revivals, sporting events, and more. In 1967 and 1968, the arena was home court for the inaugural season of the American Basketball Association's New Jersey Americans, now the NBA's Brooklyn Nets. (Courtesy of the Berdan collection.)

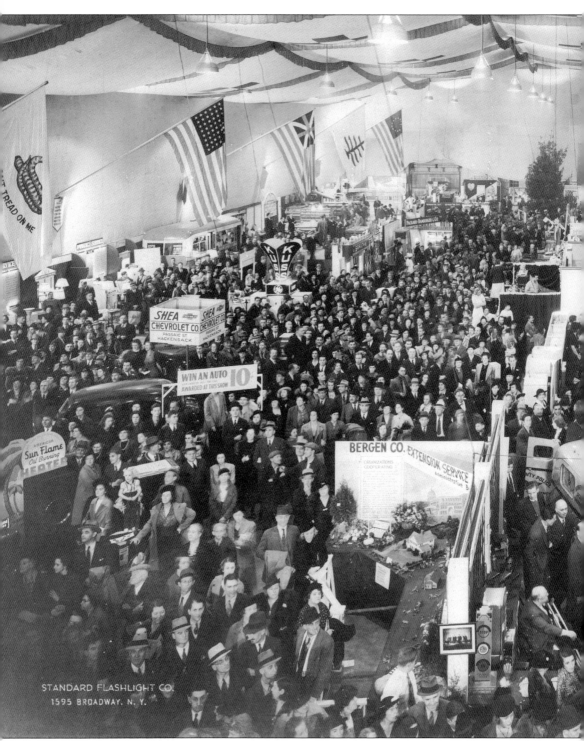

The brand-new Teaneck Armory was filled to the rafters from October 27 to November 2, 1938, for the Bergen County Home Show. Tens of thousands of people descended on "the million-dollar armory" for the household exposition, which featured a five-room model home constructed inside

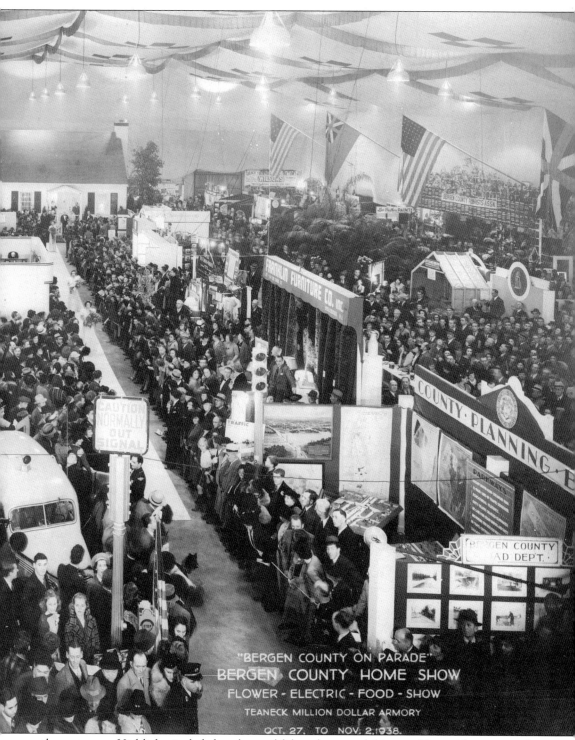

"BERGEN COUNTY ON PARADE"
BERGEN COUNTY HOME SHOW
FLOWER - ELECTRIC - FOOD - SHOW
TEANECK MILLION DOLLAR ARMORY
OCT. 27. TO NOV. 2, 1938.

the vast space. Highlights included poultry and fish and game exhibits, a public wedding arranged by the Bergen County Florists Association and officiated by Mayor Milton Votee, and a high school quiz competition with a grand prize of a trip "in a deluxe airliner." (Courtesy of Paul Cohen.)

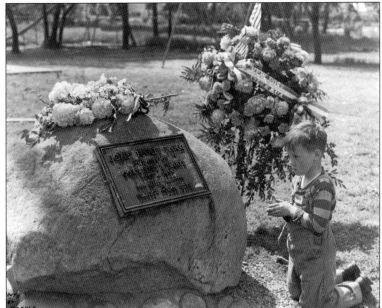

A little boy prayed at the memorial stone at the July 4, 1938, dedication of John Harte Park. The land on Glenwood Avenue was given to the township by Police Chief Cornelius J. Harte in memory of his brother, a World War I casualty. (Courtesy of the Teaneck Public Library.)

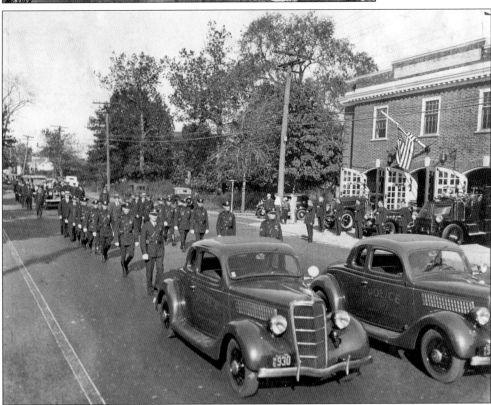

Police lieutenant Fred Davis's funeral procession moved down Teaneck Road on October 15, 1935. Davis was an 18-year veteran of the force who served temporarily as chief; he also had been a member of the volunteer Glenwood Park Fire Company. He died at age 65 after an illness of several weeks. (Courtesy of Robert Montgomery.)

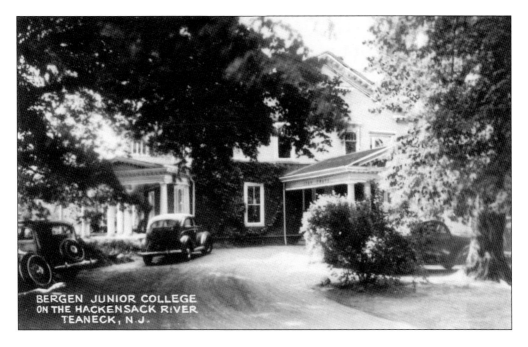

BERGEN JUNIOR COLLEGE
ON THE HACKENSACK RIVER
TEANECK, N.J.

Teaneck became a college town in 1936 when Dr. Charles L. Littel, who established Bergen Junior College at the Hackensack YWCA three years earlier, acquired an agricultural tract along the Hackensack River and relocated the school there. These postcards show an administration building, above, and a women's dormitory, below. In 1954, Bergen Junior College merged with Rutherford-based Fairleigh Dickinson College, with Teaneck becoming a Fairleigh Dickinson campus. (Both, courtesy of the Teaneck Public Library.)

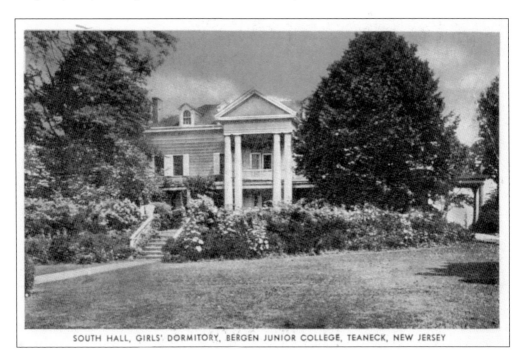

SOUTH HALL, GIRLS' DORMITORY, BERGEN JUNIOR COLLEGE, TEANECK, NEW JERSEY

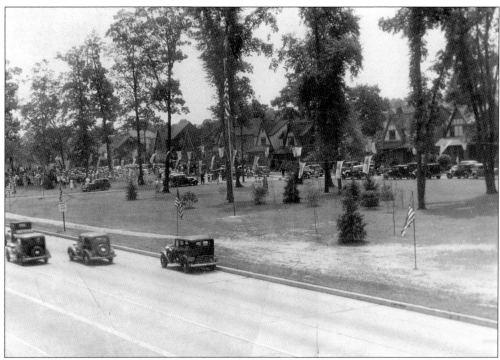

Above, motorists in 1937 pass a flag-waving Fourth of July celebration on the greenbelt separating Route 4 from homes on Woods Road. The state highway, completed in 1932, stretches 11 miles between the George Washington Bridge and Paterson and bisects Teaneck. Below is a view of Route 4 in the late 1940s. Teaneck has always barred development along its two-and-a-half-mile portion of the highway. (Both, courtesy of the Teaneck Public Library.)

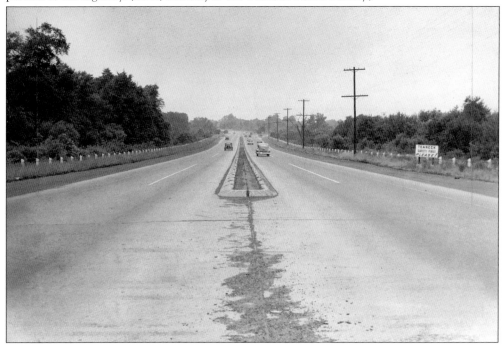

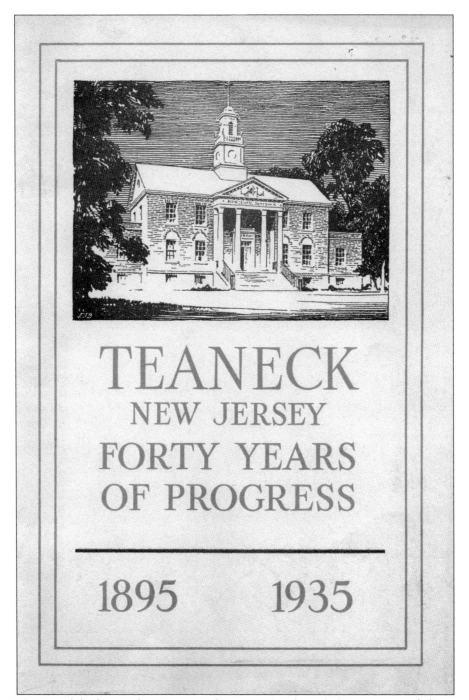

TEANECK
NEW JERSEY
FORTY YEARS
OF PROGRESS

1895 1935

In 1935, Teaneck had a population greater than 20,000 and was feeling pretty good about itself. To celebrate its 40th anniversary, the township threw a party over an October weekend and published this 28-page guide filled with information about local services, schools, and houses of worship. "We have sought to create a monument worthy of the Township which it represents and to offer its citizenry a fitting chronicle of its achievement," read the foreword. (Courtesy of the Berdan collection.)

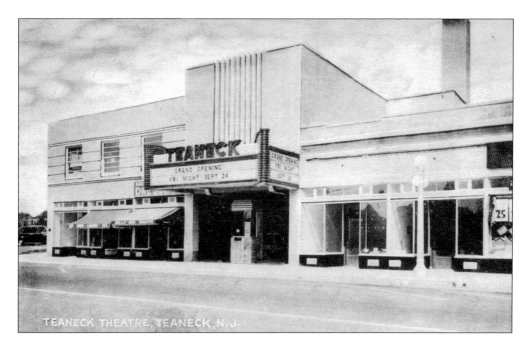

TEANECK THEATRE, TEANECK, N.J.

The Teaneck Theater on Cedar Lane, above, bowed the evening of October 21, 1937, with a screening of *Thin Ice*, starring Tyrone Power. The *Bergen Evening Record* proclaimed the movie house "one of the most beautiful and finest equipped in the state," and many of the 1,050 seats were filled with prominent citizens. Subsequent renovations preserved the Art Deco splendor of what is now the four-screen Teaneck Cinemas, seen below during the 2018 Teaneck International Film Festival. (Above, courtesy of the Berdan collection; below, photograph by Ray Turkin.)

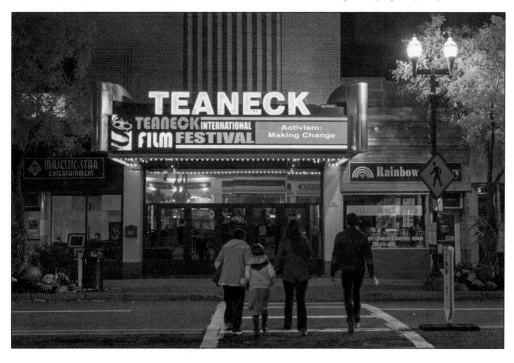

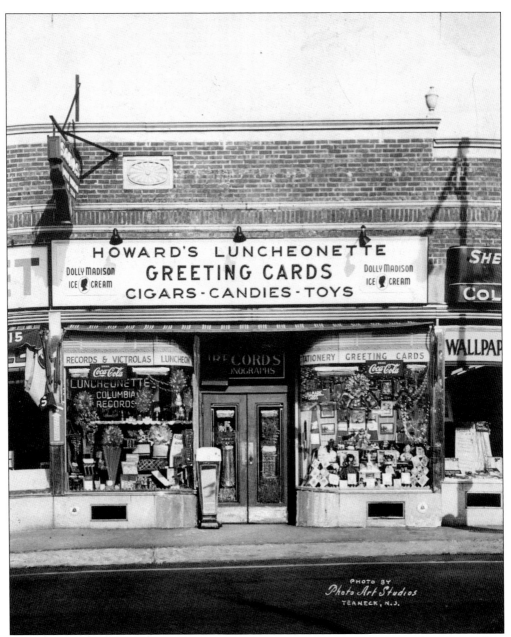

Howard's Luncheonette, at 513 Cedar Lane, opened on November 6, 1941, with Mayor Milton Votee officially welcoming Howard Cohen's new business. In addition to selling stationery, candy, tobacco, toys, and photographic products, Howard's boasted a soda fountain. (Courtesy of the Teaneck Public Library.)

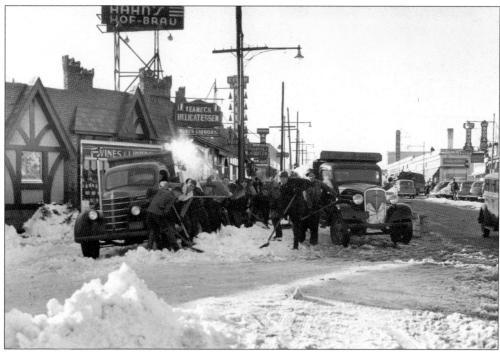

Above, it took a shovel-wielding army to clear the roadway at Cedar Lane and Front Street downtown after a February 1940 snowstorm. Below, the same storm left piles of snow alongside Queen Anne Road bordering Central (now Votee) Park. (Both, courtesy of the Teaneck Public Library.)

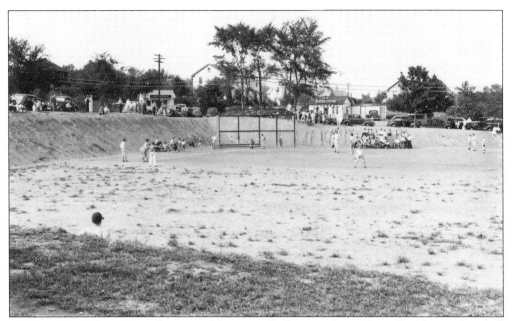

Here are scenes from the early years of Ammann Park in southern Teaneck. Above, a baseball game drew a crowd, and below, the goldfish-filled pond proved irresistible for a photographer. The park was named for Edmund Ammann, who was described in newspaper accounts as a wealthy eccentric. He bequeathed the five-and-a-half-acre parcel to the township upon his death in 1937. (Both, courtesy of the Teaneck Public Library.)

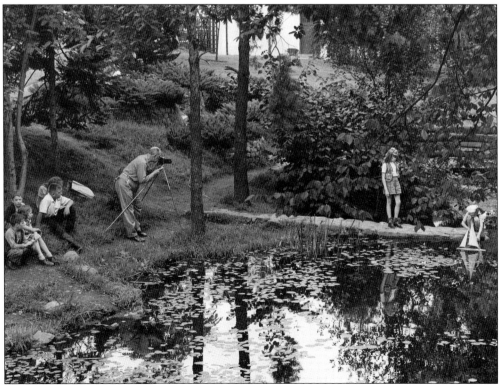

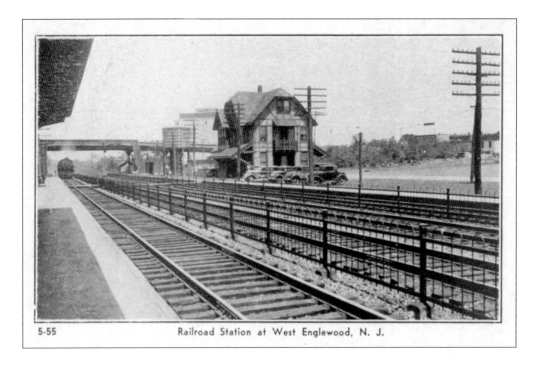

5-55 Railroad Station at West Englewood, N. J.

For 76 years, Teaneck enjoyed passenger train service on the West Shore line of the New York Central Railroad. Commuters rode the rails south to Weehawken, where they boarded ferries to Manhattan. These postcards show the township's two rail stations: the West Englewood station, above, and the Teaneck station, just north of Cedar Lane, below. (Both, courtesy of the Teaneck Public Library.)

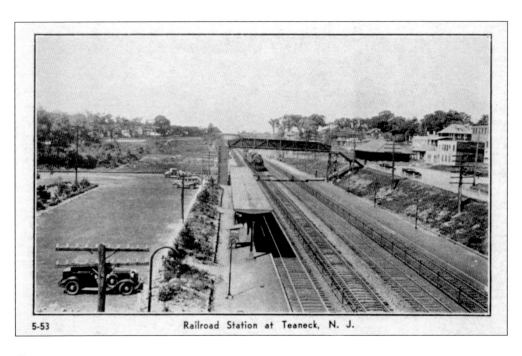

5-53 Railroad Station at Teaneck, N. J.

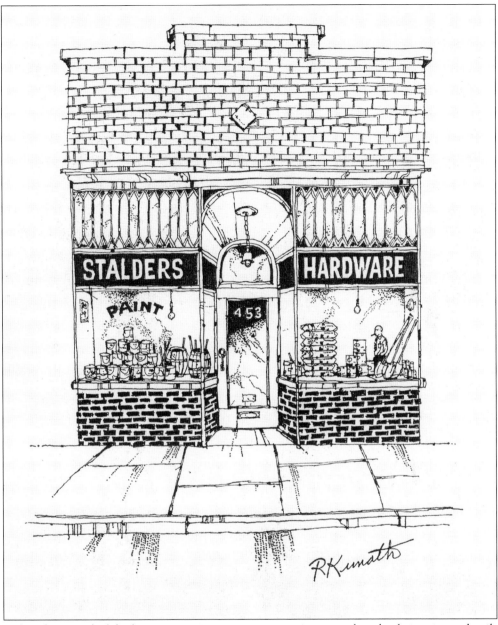

Before the arrival of the home improvement superstores, customers bought their paint and nails and snow shovels at friendly independent hardware dealers such as Goodman's, in the West Englewood section; Ludewig's, on Queen Anne Road near the Bogota border; and Stalder's, on Cedar Lane. The latter, depicted here by artist Richard Kunath, was in business from the 1920s until 1971. Goodman's and Ludewig's both lasted into the new century. (Courtesy of Cecilia Kunath.)

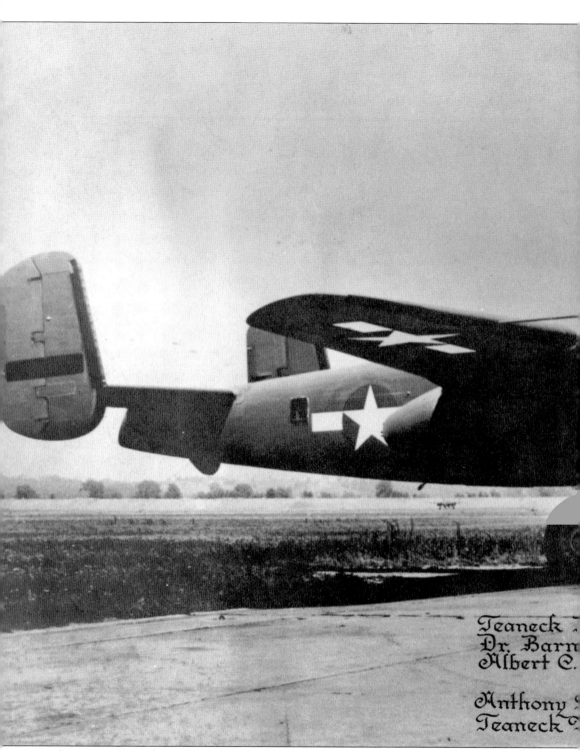

Teaneck
Dr. Barn
Albert C.

Anthony
Teaneck

The citizens of Teaneck supported the World War II effort in many ways, none more spectacularly than by buying the US Army a B-25 Mitchell bomber, the same type of twin-engine plane deployed in the historic raid over Tokyo. The *Spirit of Teaneck, N.J.* was purchased through the sale of

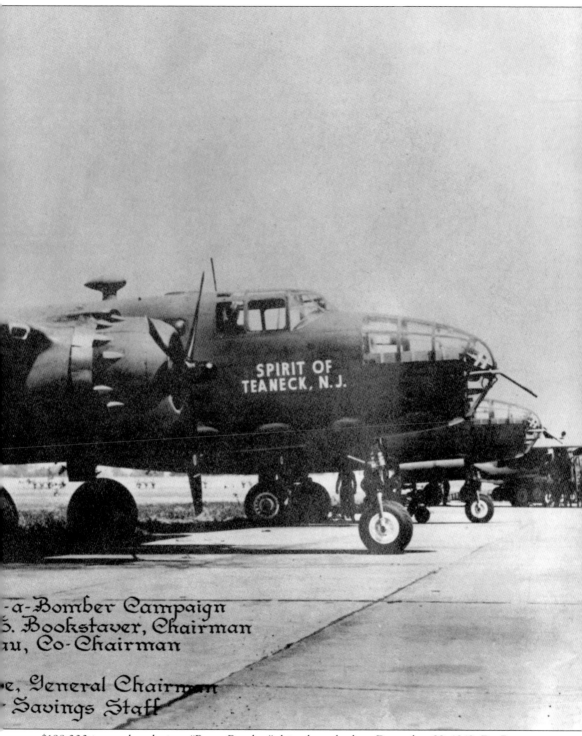

SPIRIT OF
TEANECK, N.J.

-a-Bomber Campaign
5. Bookstaver, Chairman
ru, Co-Chairman

e, General Chairman
Savings Staff

$198,000 in war bonds, in a "Buy-a-Bomber" drive launched on December 29, 1942. Dr. Barnet Bookstaver, the township health officer, led the campaign, which surpassed its $175,000 goal and culminated with a military pageant at the Teaneck Armory. (Courtesy of Mimi Bookstaver.)

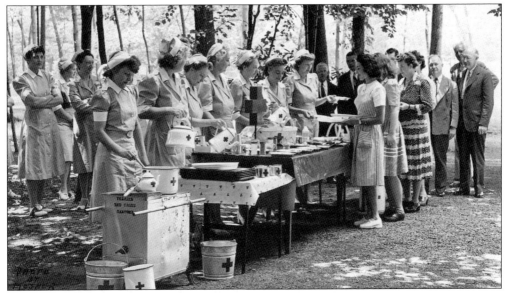

It was not haute cuisine, but the menu was pleasing enough to the 100 Teaneck residents who portrayed disaster victims on June 14, 1943, at a Red Cross training luncheon in Central Park. Canteen unit members dished out soup from a dehydrated mix, sandwiches, crullers, and coffee. "The Red Cross canteen unit showed remarkable efficiency in setting up this nutritious luncheon under normal conditions, which would be doubly appreciated under disaster conditions," said township manager Paul A. Volcker, one of the attendees. (Courtesy of the Teaneck Public Library.)

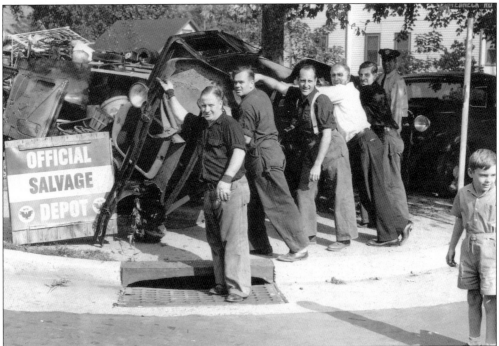

During World War II, many communities held drives to collect scrap metal, rubber, and other useful materials. Here, a group of Teaneck firefighters added an old Model A Ford to the growing scrap heap near fire headquarters on Teaneck Road. (Courtesy of the Teaneck Public Library.)

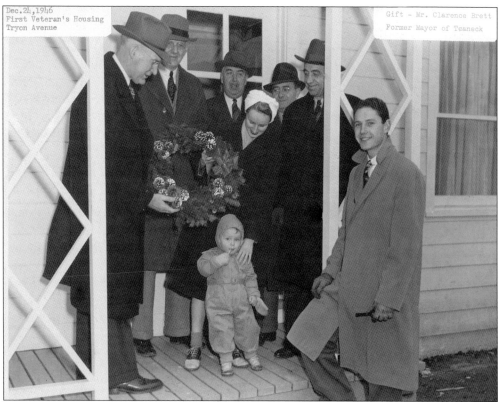

After World War II, Teaneck hurried to build housing for returning soldiers and sailors. On Christmas Eve in 1946, above, township officials bearing pine cones welcomed one young family to their new home on Tryon Avenue. Below, a child scampered through the courtyard of a veterans apartment complex on State Street. (Both, courtesy of the Teaneck Public Library.)

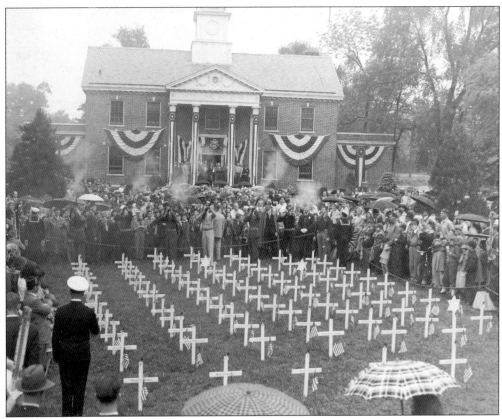

Above, throngs gathered in front of the Municipal Building on a rainy Memorial Day in 1948 to honor those from Teaneck who died in World War II. At the same spot the following Memorial Day, below, Mayor Clarence W. Brett spoke at the dedication of the marble World War II memorial bearing the names of 86 sons of the township—82 from the armed forces and four merchant mariners. (Both, courtesy of the Teaneck Public Library.)

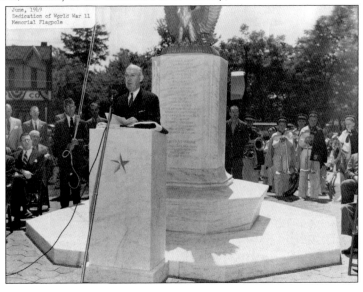

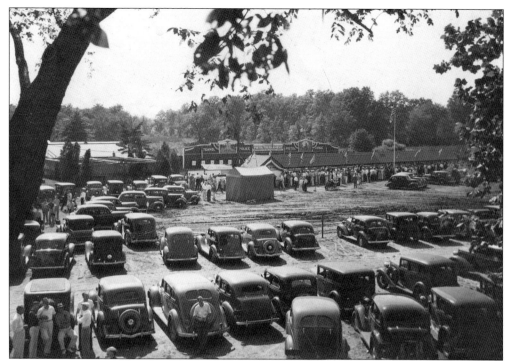

For many years, the Teaneck Police Department pistol range off River Road played host to a pistol target tournament that attracted sharpshooters from near and far. The popular event was sponsored by the *New York Mirror* newspaper. Above, cars filled the field in front of the range at the sixth annual tournament, in 1937. Below, competitors fired away at the 16th annual tournament, in 1947. (Both, courtesy of the Teaneck Public Library.)

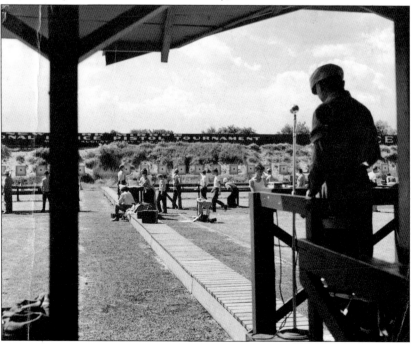

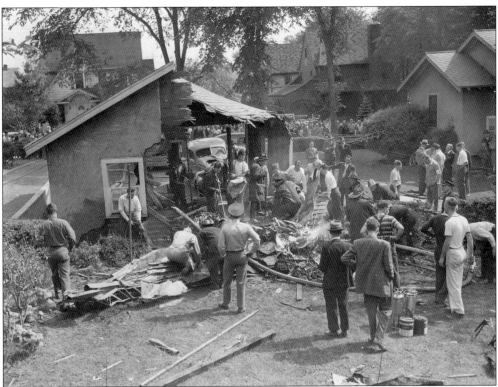

Two airplane crashes visited the same spot in Teaneck eight years apart. Above, emergency workers surveyed the garage at 890 Queen Anne Road, at Cherry Lane, after an Army plane plummeted into it on March 24, 1942. Moments earlier, the plane had collided with another Army craft while practicing wartime maneuvers. Both pilots parachuted to safety; the other plane came down on the pavement of Dartmouth Street. Below, passersby surrounded a broken Beechcraft Bonanza in the Queen Anne Road-Cherry Lane intersection on September 5, 1950. That airplane developed engine problems after leaving from Teterboro Airport. The crash killed the pilot and injured the passenger. (Both, courtesy of the Teaneck Public Library.)

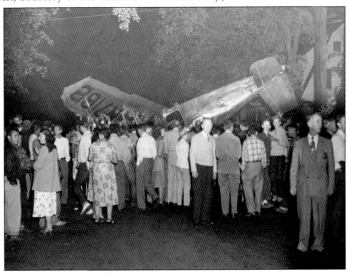

Under Dr. Barnet Bookstaver, the Teaneck Health Department offered such services as a child hygiene station where nurses could weigh and assess the township's youngest constituents. (Courtesy of Teaneck Public Library.)

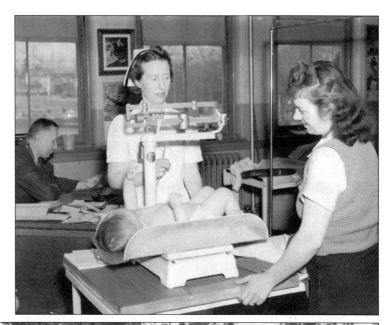

Cedar Lane & Grange Rd. Teaneck, N.J.

This row of storefronts on Cedar Lane between Queen Anne and Grange Roads has not changed much in appearance since the late 1940s, when the photograph was taken. The block's longtime anchor was the Wigwam Tavern, which made headlines in 1950 when a bookmaking ring was busted there. The Wigwam is now the Cottage Bar. (Courtesy of Mark Siegler.)

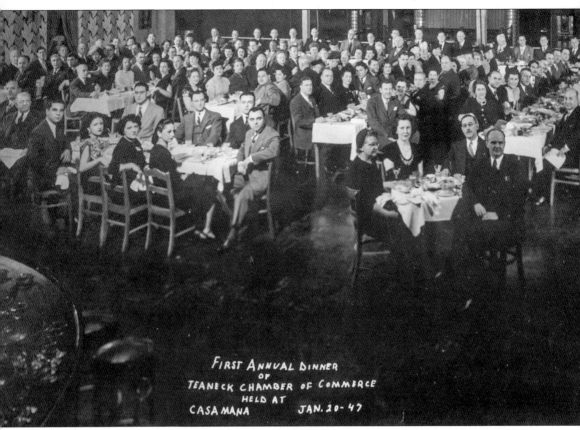

By the end of World War II, Teaneck had multiple thriving shopping districts and a need for one entity to focus on the business community. Enter the Teaneck Chamber of Commerce, which held its first annual meeting, shown here, on January 20, 1947, at the Casa Mana restaurant. Business and civic leaders heard guest speaker Harold C. Kessinger, district governor of the Rotary Club, say, "Teaneck needs five things to insure its place as Bergen County's fastest growing community. You have the first four requisites of a growing town: strategic location, friendliness, tolerance, and cooperation. And it's up to you to get the fifth necessity: organization." (Courtesy of Larry Bauer.)

Three

MODEL TOWN

*Teaneck—The U.S. Army believes this township is a pretty good place. In fact, the Army
thinks it's the model American community. Photographers from the Civil
Affairs Division of the army descended upon the Township yesterday with their
cameras, and started shooting. They began the first of 3 days of picture
taking. The photographs will help to make up an exhibit for the U.S. Reorientation Program in
occupied countries. The tax department had to do the posing yesterday. Photos were
taken of the collector and the auditor, who was in the act of paying an employee.*

—The *Bergen Evening Record*, September 20, 1949

Four years after victory in World War II, the US Army went looking for the "model" community—a
place that typified democracy in action. Teaneck was chosen from among 10,000 American towns,
and photographs chronicling three days in the life of the leafy suburb were shown in Japan and
other occupied countries.

The images selected for the exhibit captured ordinary but telling moments such as public
meetings, citizens transacting business in the Municipal Building, and children making music
in a school classroom. "This series of pictures shows how the town of Teaneck is governed, and
reflects the friendliness and informality that mark the relationship of government and people in
this democratic town," the Army said.

The model community basked in the honor. "All people of Teaneck," township manager Paul
A. Volcker said, "feel pride and satisfaction in this national recognition."

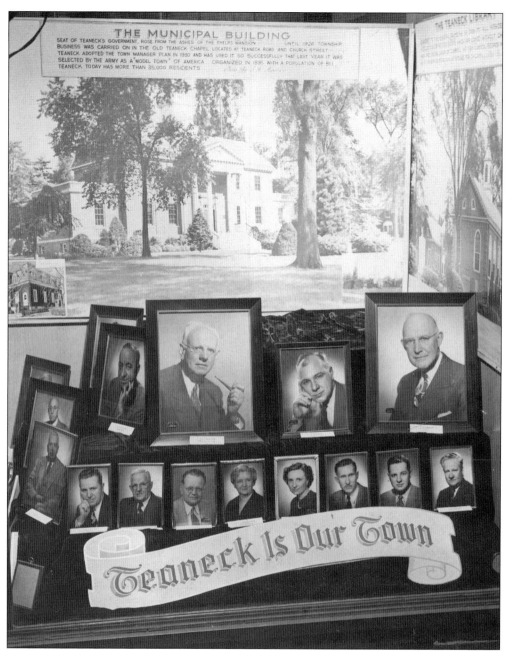

Teaneck's selection as a model community was both an object of pride and a selling point. "Live in beautiful Teaneck, the model town!" the Floyd H. Farrant realty company exclaimed in classified advertisements. The township, too, was quick to toot its own horn. This library display, in conjunction with the honor, focused on familiar landmarks and local movers and shakers. (Courtesy of the Teaneck Public Library.)

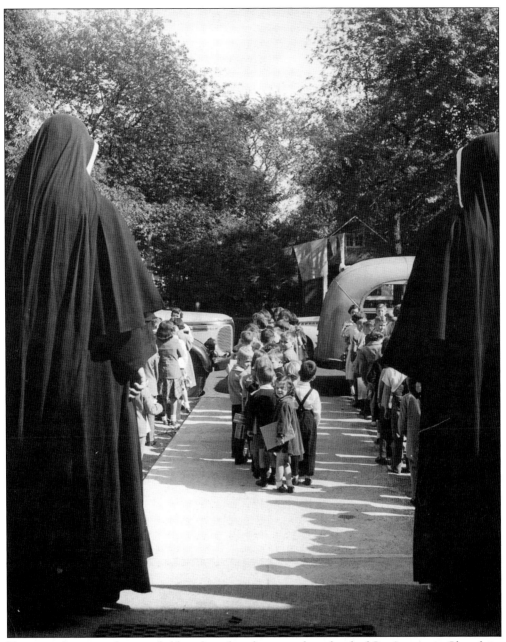

Two nuns keep watch over children boarding buses at the school of St. Anastasia Church in 1949. This photograph was included in the US Army's model town exhibit. The parish school was started in 1933 by Fr. Silverius J. Quigley upon his arrival. The school got its own building, around the corner on Teaneck Road, in 1951. St. Anastasia School closed in 1990, a victim of dwindling enrollment. (Courtesy of the Teaneck Public Library.)

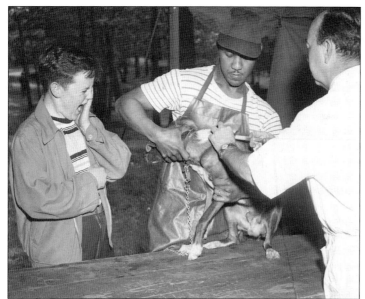

A pooch received its required township inoculation, but it was the animal's young master who felt the pain. This photograph was part of the Army's documentation of Teaneck as the model American community. (Courtesy of the Teaneck Public Library.)

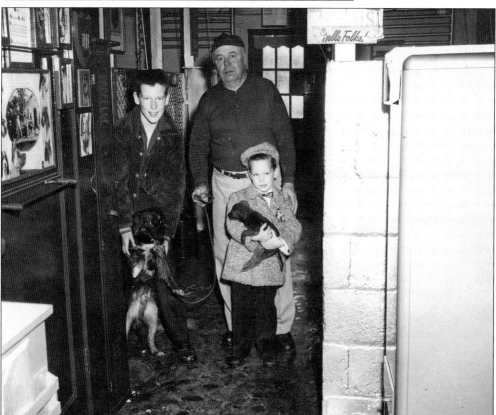

Cornelius Van Dyk, the police department's dog warden for 30 years, posed with a couple of young constituents and their furry friends. Not only was Van Dyk in charge of dog licensing and rounding up strays, but he helped found the Volunteer Ambulance Corps. (Courtesy of the Teaneck Public Library.)

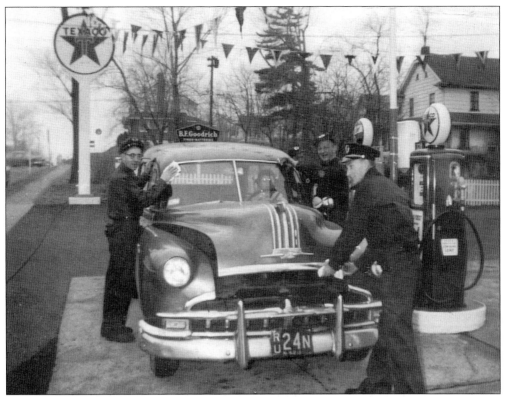

A woman at the wheel of a Pontiac got the royal treatment at the Texaco station on Cedar Lane. While Teaneck motorists still have their gas pumped for them—New Jersey prohibits self-service—this kind of attention is certainly a thing of the past. Today, the station is Teaneck Shell. (Courtesy of Ken DeVries.)

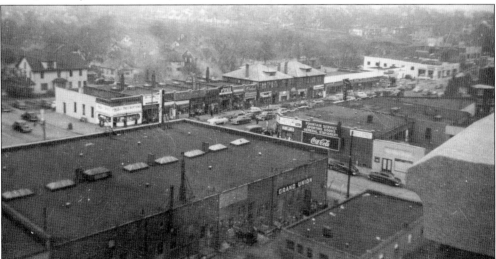

Emmett Francois was a kid living on Belle Avenue when he took this photograph of the Cedar Lane business district, and the neighborhood beyond, from an apartment building rooftop in 1951. Francois would become a professional news photographer. More of his work appears in later pages of this book. (Courtesy of Judith Distler.)

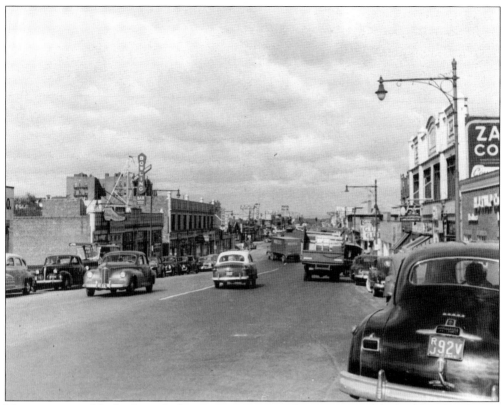

Here are views of Cedar Lane, looking west, in 1949 and 2019. Many of the building facades are unchanged, and one business in particular has persevered: H.J. Tulp Company, an insurance and real estate agency, seen in the squat brick building at the right of each photograph. (Above, courtesy of the Teaneck Public Library; below, photograph by Ray Turkin.)

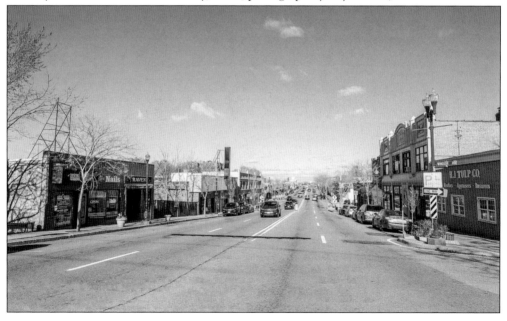

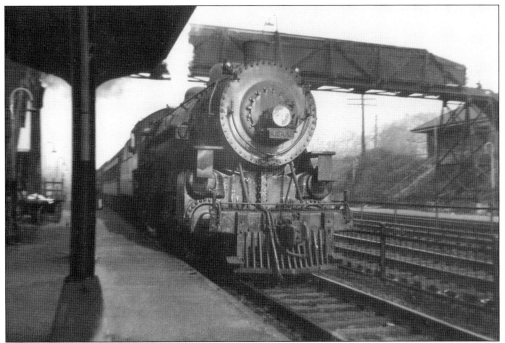

In the early 1950s, the New York Central Railroad switched from steam to diesel power on the West Shore line, which many Teaneck residents used for their Manhattan commutes. Above, a steam-powered locomotive pulled a commuter train through Teaneck; sometime later, below, a diesel locomotive did the job. (Both, photographs by Emmett Francois; courtesy of the Teaneck Public Library.)

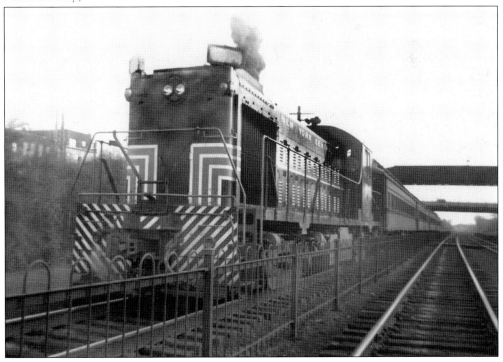

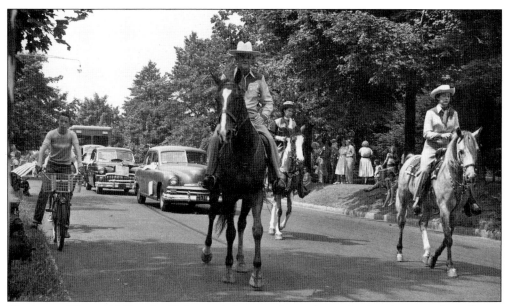

The route of Teaneck's Fourth of July parade has not changed over the decades—north on Queen Anne Road, past the high school, under Route 4, and ending at Central (now Votee) Park. The four photographs on this page and the next page show the progression of the 1952 parade. (Both, courtesy of the Teaneck Public Library.)

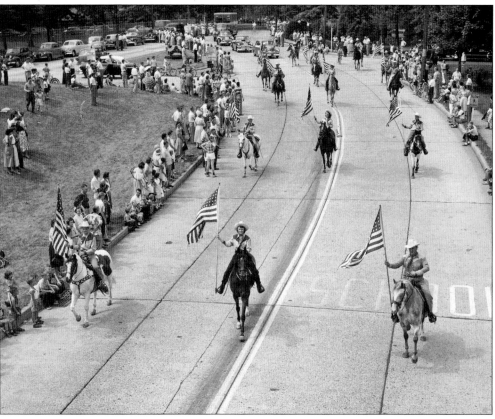

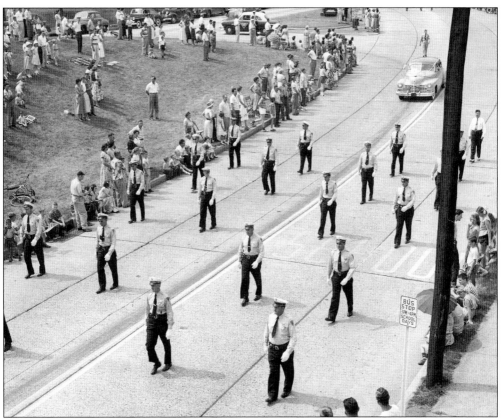

The photographs on this page were taken just before the Fourth of July parade was about to pass under Route 4. Below, dignitaries watched from a reviewing stand next to the fence enclosing the Teaneck High School athletic field. (Both, courtesy of the Teaneck Public Library.)

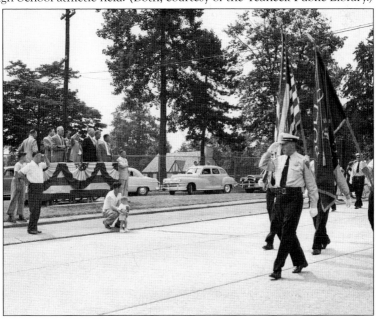

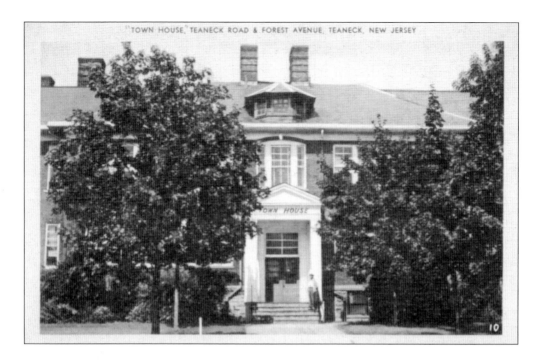

The Town House, formerly School No. 2, played host to community meetings and an array of clubs. But to teenagers in the 1940s and 1950s, the Town House, above, was best known for the Little Brown Jug, a youth organization renowned for its parties and dances, like the hoedown pictured below. Succeeded by the Richard Rodda Community Center in 1998, the Town House saw the wrecking ball two years later. (Both, courtesy of the Teaneck Public Library.)

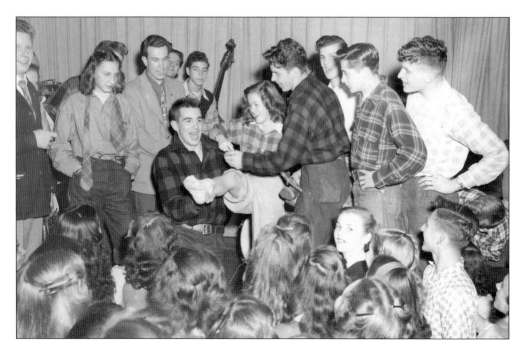

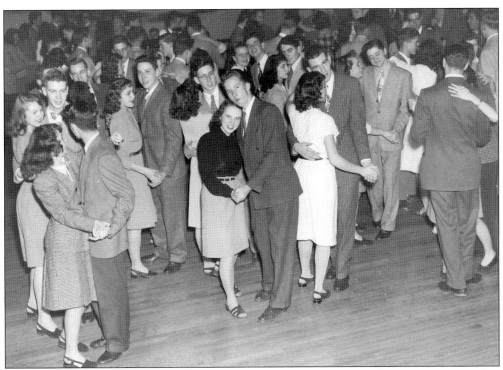

Above, teenage couples swooned at one of the dances that made the Town House the place to be. At right, these boys slipped away to the washroom to make sure they looked their best. (Both, courtesy of the Teaneck Public Library.)

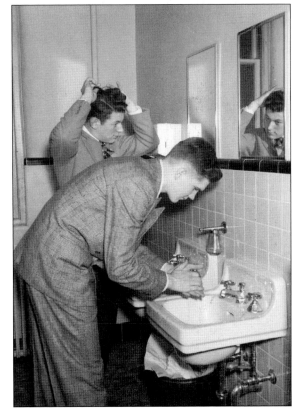

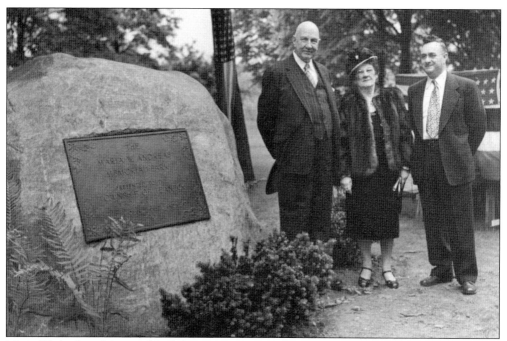

Maria W. Andreas Memorial Park, between River Road and the Hackensack River, was dedicated on May 30, 1952. Frederic Andreas, left, donated his family's land for the creation of the park, with the stipulation that it be named for his mother. With Andreas at the ceremony were his wife, Mabel, and deputy mayor Cecil Haggerty. (Courtesy of the Teaneck Public Library.)

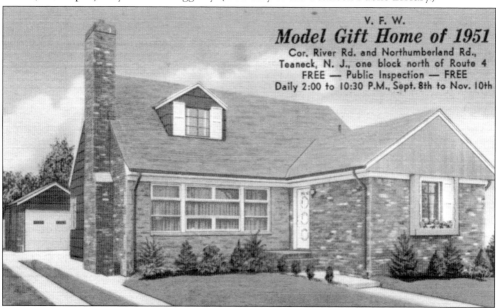

"It's a castle of dreams," the *Bergen Evening Record* said of this newly built five-room house at 1165 River Road, which the Veterans of Foreign Wars offered as grand prize on the final night of the 1951 Bergen County Home Show at the Teaneck Armory. The lucky winner of the fully furnished house and 6,000-square-foot lot—valued at $30,000—was North Bergen, New Jersey, housewife Wilma Stitz. (Courtesy of the Berdan collection.)

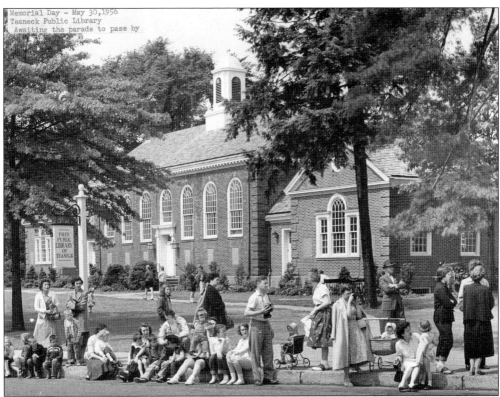

Above, parade-watchers staked out a spot in front of the Teaneck Public Library on Memorial Day, 1956. Below, teenagers congregated around the circulation desk during the same era. Teaneck's first lending library was established in 1913 when Louise Jordan placed donated books in her sun parlor. As the township grew, so did the need for a taxpayer-supported library. The Georgian-style Teaneck Public Library, next to the Municipal Building, was dedicated in 1927. Today, it is the second-busiest library in Bergen County, with a total circulation of 432,818 books, DVDs, and other items in 2018. (Both, courtesy of the Teaneck Public Library.)

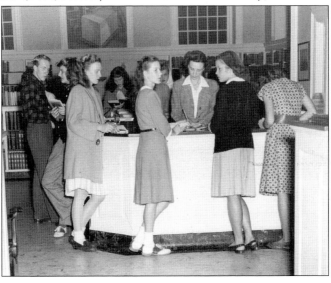

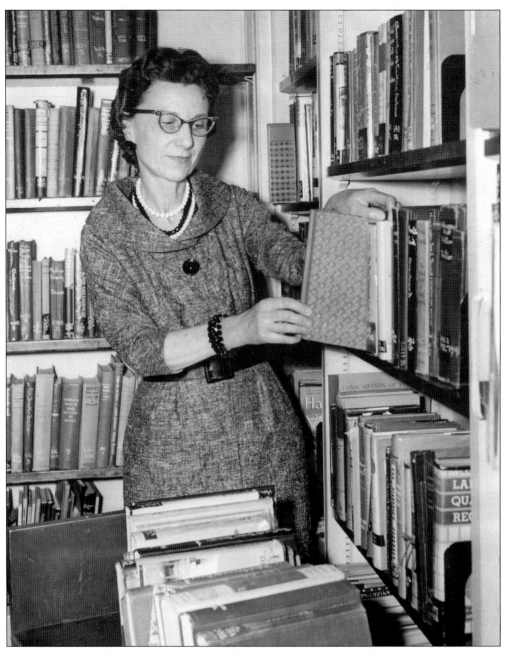

Agnes Norton, in charge at the Teaneck Public Library from 1929 to 1961, oversaw renovations and expansions and introduced a host of innovations, such as the lending of record albums. Under Norton, Teaneck's library was lauded by *Library Journal* magazine "as one of the pioneers in the use of color in its decorations and furnishings." The busy library director found time to read three to five books a week. "Books are my life," she said. "I will probably never write one but there is the joy of holding a book, leafing through it, and knowing it opens up another world to me." (Courtesy of the Teaneck Public Library.)

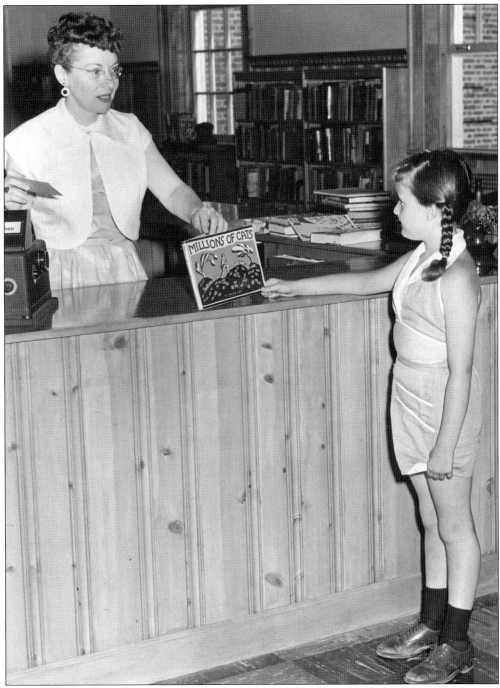

The Teaneck Public Library's new junior wing opened July 1, 1953, and the first patron checked out the classic *Millions of Cats*. Another wing incorporating a reference room opened at the opposite end of the building later that year. (Courtesy of the Teaneck Public Library.)

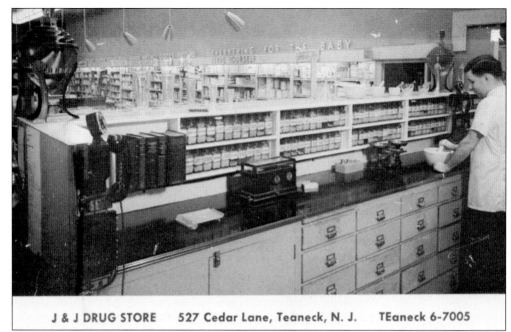

J & J DRUG STORE 527 Cedar Lane, Teaneck, N. J. TEaneck 6-7005

Above, Jacob Robbins compounded medications behind the counter at J&J Pharmacy in the 1950s. Robbins and Jerome Kantor opened the drugstore in 1946 at Cedar Lane and Elm Avenue. Owned by Michael Fedida, RPh, since 1987, J&J today competes with a CVS and a Walgreens on the other side of the street. The photograph below, from the same era, shows the interior of Hirschmann's Pharmacy on Queen Anne Road, in the West Englewood section. Now Parkview Pharmacy, it has been owned by David Teichman, RPh, since 1978. (Above, courtesy of Michael Fedida; below, courtesy of David Teichman.)

In 1957, Fire Chief William Lindsey Jr., left, and Inspector Charles R. Montgomery, right, showed the staff of Brightside Manor how to operate the alarm box outside the Teaneck Road nursing home. (Courtesy of the Teaneck Public Library.)

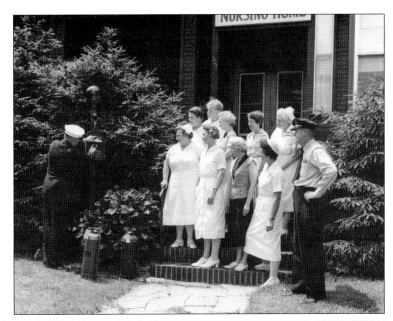

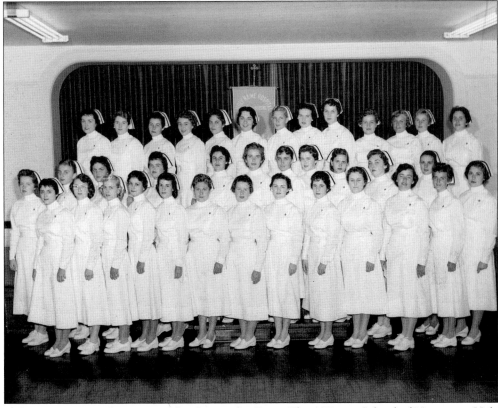

Holy Name Hospital's nursing school, now the Sister Claire Tynan School of Nursing at Holy Name Medical Center, opened in 1925. Here is the class of 1957. The hospital has produced more than 4,000 registered nurses and 900 licensed practical nurses in its 95 years. (Courtesy of Holy Name Medical Center.)

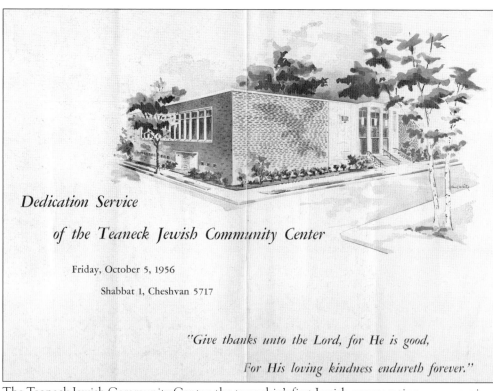

The Teaneck Jewish Community Center, the township's first Jewish congregation, was organized in 1933. Services were initially held at artist Israel Doskow's studio. A synagogue was built at Prince Street and Sterling Place in 1949 and expanded several years later to include a social hall, gymnasium, and swimming pool. Above, the enlarged synagogue is depicted on the dedication service program. The "shul with a pool" is now the Jewish Center of Teaneck. Below, Eleanor Roosevelt was a guest speaker at an Israel Bonds dinner at the synagogue on December 13, 1955. With the former first lady were Mayor Henry Deissler, standing, and Councilman Adolf C. Robison. (Above, courtesy of Abbe Rosner; below, photograph by John T. LaMont, courtesy of Mary Jane Leenstra.)

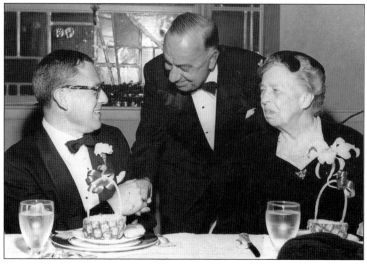

The Bergen County Reform Temple, the region's first Reform Jewish congregation, was organized by several dozen Teaneck families in 1947. The congregation moved to this building on Larch Avenue in 1951; by the time it dedicated a new building on Windsor Road in 1959, the congregation was named Temple Emeth. The Larch Avenue building today houses the Ethical Culture Society of Bergen County. (Courtesy of Judith Sigel Fox and David Fox.)

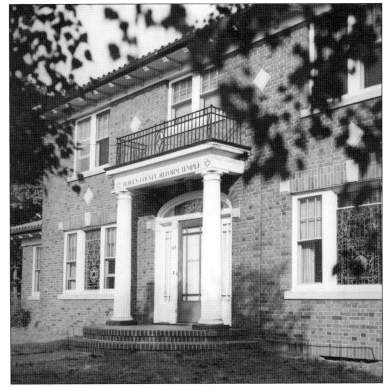

The First Baptist Church of Teaneck was organized in 1935, the congregation meeting in a local Masonic hall and then in members' homes. The following year, Maria E. Decker gifted a parcel on Teaneck Road for construction of a church building. The first service in the white clapboard chapel was on Thanksgiving morning in 1936. Rev. Lester Van Saun, the founding pastor who served for 37 years, is pictured in front of the church. A new church building was dedicated on the site in 1997. (Courtesy of First Baptist Church of Teaneck.)

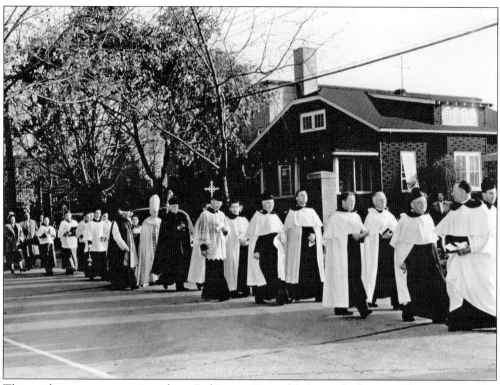

This mid-century procession along Robinson Street likely marked a special occasion at St. Anastasia Church because of the presence of Newark archbishop Thomas J. Walsh, wearing the tall white miter. Ahead of Walsh in the procession, in the center of the photograph, is St. Anastasia's pastor, Fr. Silverius J. Quigley, wearing a black biretta, looking straight ahead, and holding a piece of paper in his left hand. Quigley led the parish from 1933 to 1960. (Courtesy of St. Anastasia Church.)

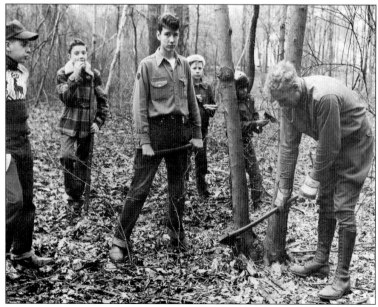

In 1953, young volunteers helped tidy up a forest for the creation of Tokoloka Park, in Teaneck's northwest corner. Once part of the estate of Christian Cole—whose c. 1860 Italianate home still stands on River Road—the 11-acre tract was never developed because of its pond. (Courtesy of the Teaneck Public Library.)

Decades before computers, township officials demonstrated at mid-century how a homeowner's tax bill was generated. All pertinent data was filled in by the accounting machine, with a perforated stub for each tax quarter. The stub was kept by the tax collector's office when payment was made, with the rest of the form going back to the homeowner for the next payment. (Courtesy of the Teaneck Public Library.)

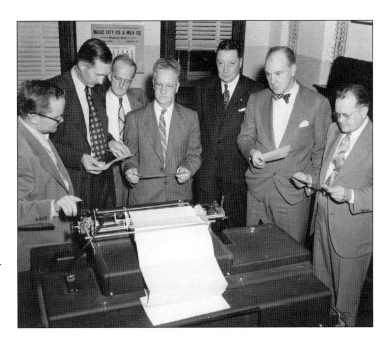

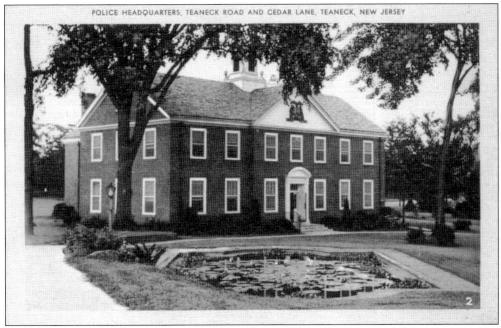

The Teaneck Police Department moved from the basement of the Municipal Building to a new Colonial-style headquarters next door in 1951. This remained the home of the force until 1994, when the current headquarters opened nearby. The original building is today part of the overall municipal complex. (Courtesy of the Teaneck Public Library.)

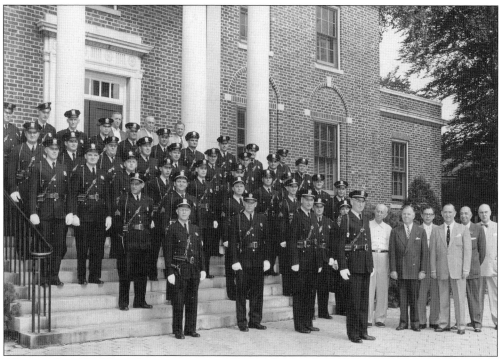

Above, Police Chief Cornelius J. Harte stood seventh from right in this 1954 departmental portrait on the Municipal Building steps. The World War I veteran led the force for 38 years. At the wheel of his cruiser, below, Harte spoke with township assistant manager Werner Schmid, left, and township manager James Walsh, right. November 10, 1965, was declared "Police Chief Cornelius J. Harte Day" in Teaneck upon his retirement. (Both, courtesy of the Teaneck Public Library.)

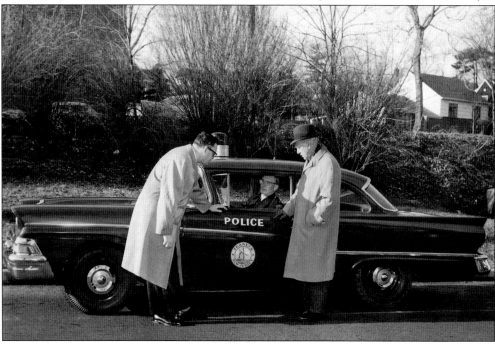

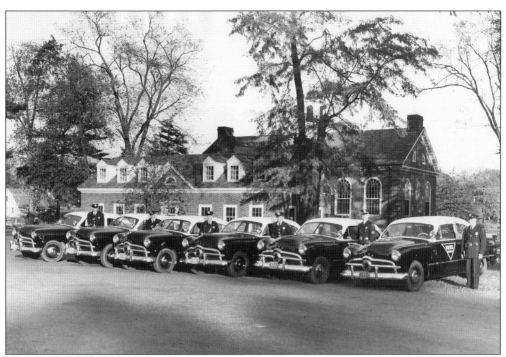

These photographs show both the evolution of Ford Motor Company styling and the Teaneck Police Department's pride in its fleet. Officers posed with their new cruisers at the beginning of the 1950s, above, and toward the end of the decade, below. (Both, courtesy of the Teaneck Public Library.)

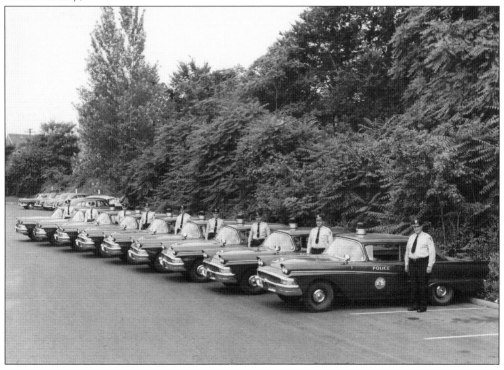

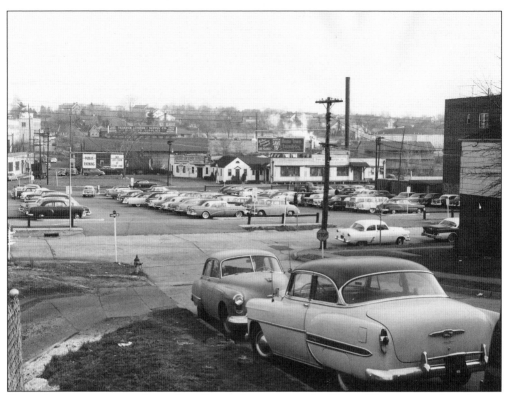

Teaneck supports its merchants by offering free municipal parking. Here are two busy lots in the 1950s: above, off Chestnut Avenue in the Cedar Lane business district and, below, between Queen Anne Road and Palisade Avenue in the West Englewood business district. (Both, courtesy of the Teaneck Public Library.)

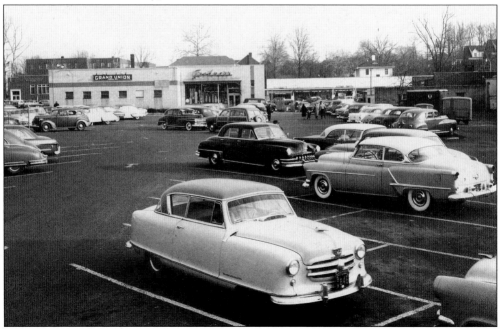

A township worker installed new white street signs bearing the name "TEANECK" in 1957 at the intersection of Cedar Lane and Teaneck Road. The municipal complex is seen in the background. Township street signs today are bright blue and do not include the Teaneck name. (Courtesy of the Teaneck Public Library.)

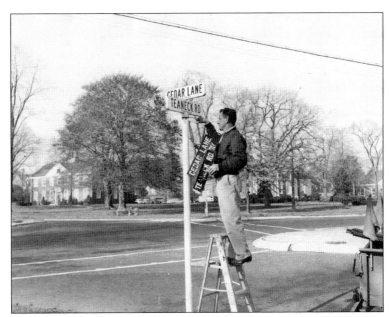

Under Francis A. Murray, chief from 1932 to 1957, the Teaneck Fire Department became a leader in fire prevention efforts. Here, the department set up an educational display about hazards such as debris, smoldering cigarettes, and unattended electric irons. Before coming to Teaneck, Murray ran fire prevention courses for departments on the East Coast. (Courtesy of the Teaneck Public Library.)

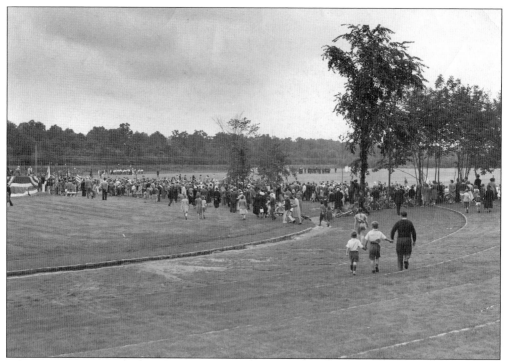

Central Park was created in 1940 from reclaimed swampland the township acquired for delinquent taxes and rededicated on July 4, 1959, as Votee Park, in honor of Milton Votee, the mayor who secured the Works Progress Administration grant that funded the construction. Above, residents converged on the park's amphitheater for a celebration in the late 1950s. Below, a 2019 photograph shows the Sportsplex, an artificial turf field added in 2014. (Above, courtesy of the Teaneck Public Library; below, photograph by Ray Turkin.)

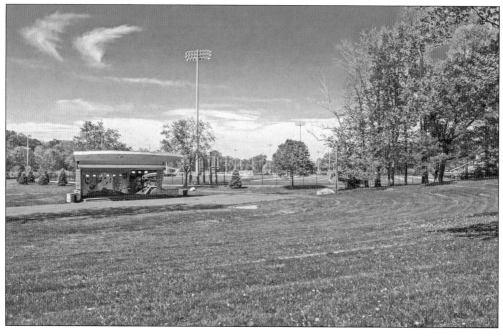

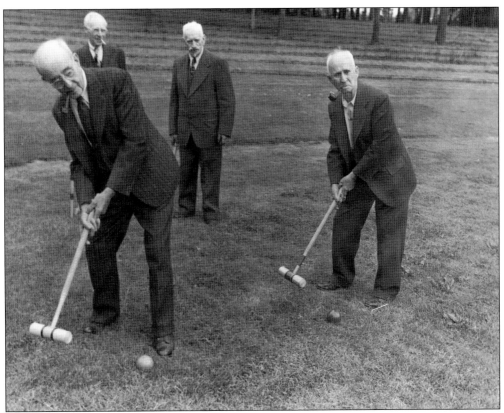

The Retired Men's Club was started by the Teaneck Recreation Department in 1947. Activities typically included cards, checkers, and chit-chat at the Town House, but the gentlemen also got out and about in the sunshine, including a round of croquet in Central Park, above, and marching in a Fourth of July parade, below. (Both, courtesy of the Teaneck Public Library.)

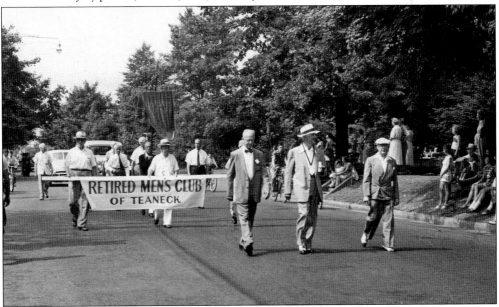

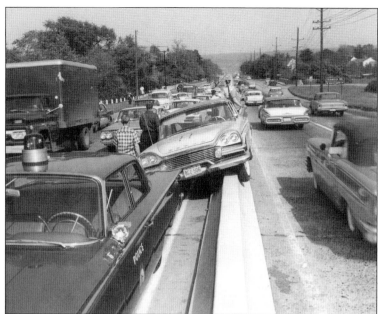

Traffic jams on Route 4 are a fact of life in Teaneck. But this backup near the Teaneck Road exit in the early 1960s was something else. There is no telling how that Dodge wound up on the divider. (Photograph by Emmett Francois; courtesy of the Teaneck Public Library.)

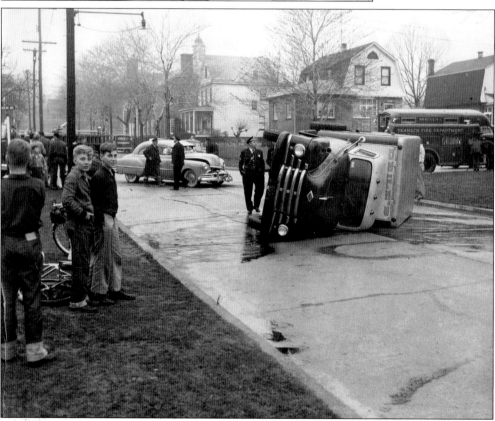

This 1955 accident on Fairview Avenue brought out the neighborhood kids. The driver of a meat delivery truck suffered minor scratches when his vehicle collided with a Pontiac and fell on its side. (Courtesy of Robert Montgomery.)

Four

PROGRESSIVE SUBURB

Teaneck, N.J., Feb. 9—The advocates of integration won a decisive victory tonight over the supporters of a neighborhood school system. The three candidates endorsing the continuation of an integrated central sixth grade, begun last fall to end de facto segregation of a predominantly Negro elementary school, defeated by a comfortable margin the three candidates campaigning for an end to the central school . . . The total number of votes cast—12,820—was a record and the campaign was one of the bitterest school fights in the history of Bergen County.

—The *New York Times*, February 10, 1965

When African American contractor James Payne purchased land in northeast Teaneck in 1951, the township was virtually all white. By the time Payne moved into the ranch-style house he built on Englewood Avenue, white homeowners in that part of town had begun selling off to black families.

The ensuing "white flight" created a racial imbalance in the school system, with the neighborhood's elementary school, Bryant, growing increasingly black—more than 50 percent so by 1964. To counter the threat of segregation, the board of education voted in 1964 to convert Bryant to a central sixth grade and send northeast Teaneck's younger students to elementary schools throughout the township. The plan, crafted by school superintendent Harvey B. Scribner and achieved through busing, went into effect that September.

The hotly debated move was affirmed months later when township voters elected a school board majority supportive of integration. In voluntarily integrating its public schools, Teaneck, New Jersey, made history.

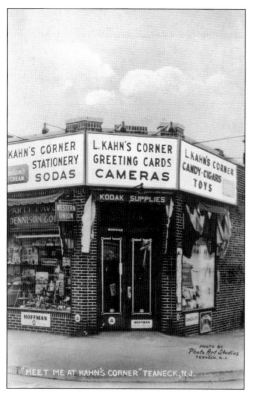

For more than 80 years, Teaneck residents have relied on the corner stationery store in the heart of the Cedar Lane business district for newspapers, magazines, candy, and sundries. It was originally Kahn's Corner, left, and around 1960, it became Rocklin's. Below, Mayor Matthew Feldman, third man from left, snipped the ribbon marking the change in ownership. (Below, photograph by Emmett Francois; both, courtesy of the Teaneck Public Library.)

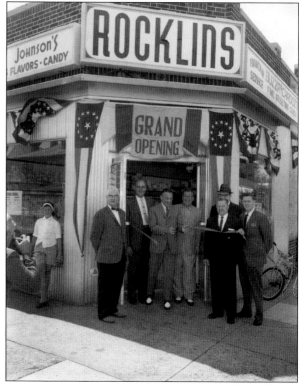

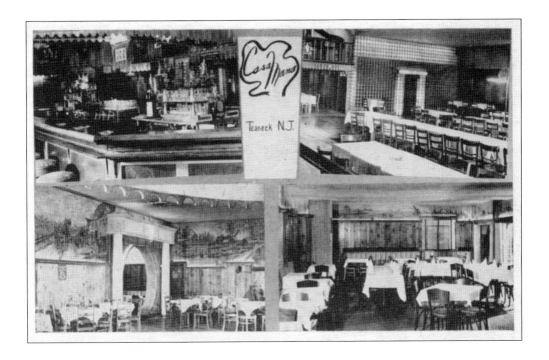

Above, Casa Mana on Cedar Lane was a popular venue for political and business dinners, committee meetings, weddings, and anniversary parties. Its motto was "dinner for one or 1,000." The supper club was replaced in 1966 by a ShopRite supermarket, below, which joined three other groceries on the main shopping thoroughfare. (Both, courtesy of the Teaneck Public Library.)

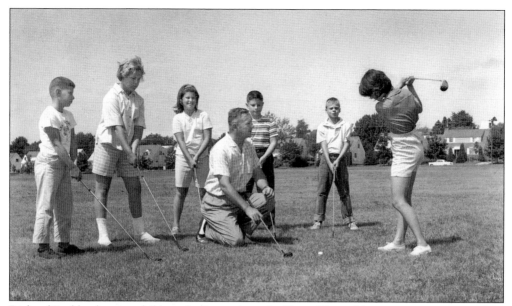

Richard Rodda, showing children the fine points of golf, was Teaneck's recreation superintendent from 1944 to 1983. "Most people think of recreation as a bat and ball and a kid in an open field," Rodda said in a 1966 interview. He took a more expansive view. Rodda helped expand the park system through the acquisition of vacant land and launched activities such as children's summer camps, art and drama programs, outdoor concerts, and clubs for senior citizens. The recreation center at the southern end of Votee Park is named for him. (Photograph by Emmett Francois; courtesy of the Teaneck Public Library.)

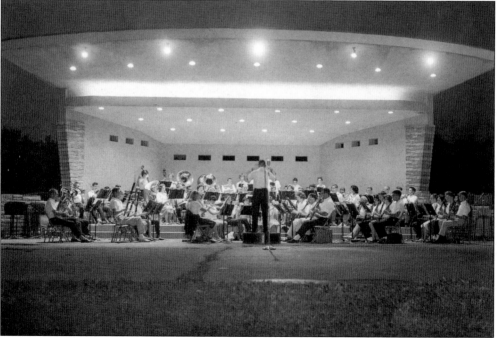

For decades, summer concerts and movies under the stars have been a staple at the Votee Park band shell. (Photograph by Emmett Francois; courtesy of the Teaneck Public Library.)

This view from Teaneck Road shows the construction of Interstate 80 in the early 1960s. Scores of homes in southernmost Teaneck were demolished to make way for the highway, which stretches for 2,900 miles between San Francisco and the junction of Interstate 95 in Teaneck. (Photograph by Emmett Francois; courtesy of the Teaneck Public Library.)

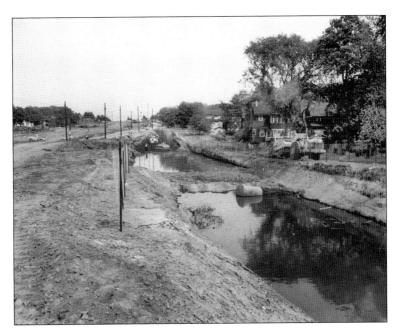

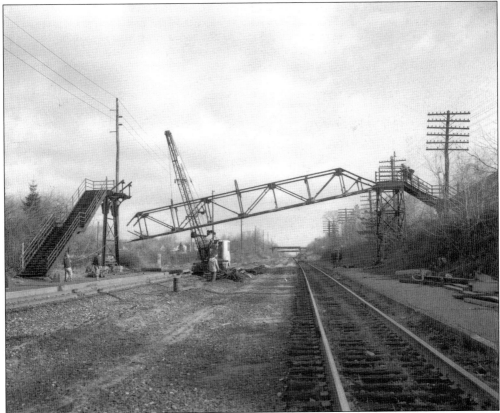

Passenger train service on the West Shore line ended on December 10, 1959, and the footbridge spanning the tracks at the Teaneck station was dismantled two years later. (Photograph by Emmett Francois; courtesy of the Teaneck Public Library.)

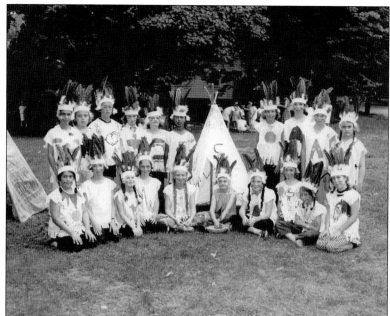

A generation of Brownies and Girl Scouts enjoyed outings to the Little House, which was just that—a little house but at a prominent location: beside Route 4. These Brownies pose with their teepee in 1960. The Little House was later used by the Police Athletic League. (Courtesy of Lorraine Peter.)

The Teaneck police are always there to assist. Officer Jim McCall helped Frances Petrower make a call from a River Road telephone booth knocked over by vandals on a winter day in 1968. (Photograph by Al Paglione; courtesy of the Teaneck Public Library.)

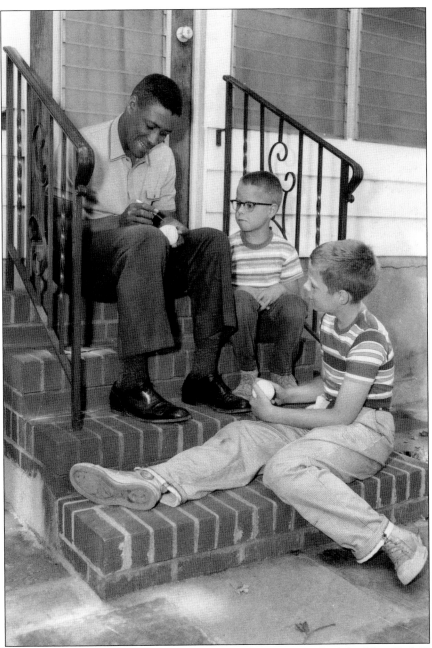

Relaxing on the stoop of his first Teaneck home, Elston Howard of the New York Yankees autographed baseballs for a couple of young admirers. Howard, the Bronx Bombers' first African American player, excelled as a catcher, outfielder, and first baseman during 13 seasons. He used his 1962 World Series bonus to build a larger house, on Edgemont Place. Howard, who attended Little League games and other events around town, died much too soon at age 51. Two other notable Yankees, Hall-of-Famer Dave Winfield and *Ball Four* author Jim Bouton, also called Teaneck home. The town's most accomplished homegrown major leaguer is Doug Glanville, who graduated from Teaneck High in 1988 and played for the Philadelphia Phillies, Chicago Cubs, and Texas Rangers. (Photograph by Emmett Francois; courtesy of Judith Distler.)

Bowl in Complete Comfort

On the most
Beautiful Alleys in the World

AUTOMATIC PIN SETTERS —
AUTOMATIC TELEFOUL —
TELESCORE – AIR-COOLED

Latest
Scientific Lighting
and Sound proofing

FEIBEL'S RECREATION
730 PALISADE AVE.
TEANECK, N.J.

PHONE·
TEANECK
6-1288

BAR

LUNCHEONETTE

Feibel's bowling alley on Palisade Avenue hosted league and recreational play for 46 years. The 32 lanes had a corner-bar atmosphere, so it was not surprising when comedian Rodney Dangerfield, mystery writer Mickey Spillane, and on-again, off-again New York Yankees manager Billy Martin showed up one day to film a television commercial for Miller Lite beer. The pins stopped falling at Feibel's in 1987. (Above, courtesy of the Berdan collection; below, author's collection.)

BOWLERS GUIDE

FEIBEL'S RECREATION CENTER
730 Palisade Avenue • Teaneck, New Jersey
Telephone: TE 6-1288

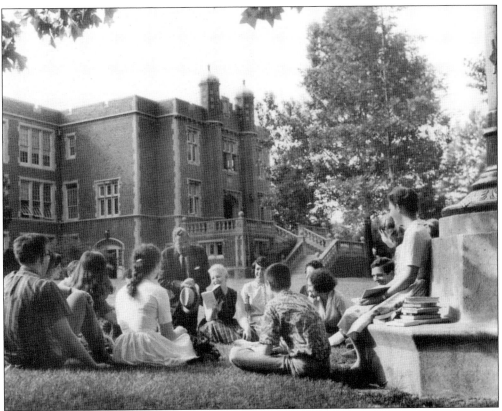

William Moore, here leading a class on the lawn in 1962, was an eminent presence at Teaneck High School for four decades—much of the time as English department chairman. The man who introduced generations of students to creative writing moonlighted on the township Library Board and was often seen bicycling about town. (Photograph by Emmett Francois; courtesy of the Teaneck Public Library.)

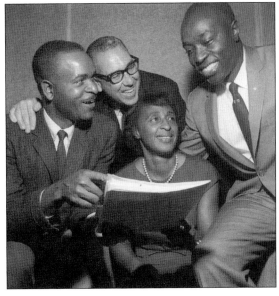

Isaac McNatt, a son of North Carolina sharecroppers, became Teaneck's first African American councilman in June 1966 when he was appointed to a vacancy on the governing body. He won a full term that November. McNatt, right, reviewed vote totals on election night with, from left to right, campaign managers Archie Lacey and Robert Mandelkern and his wife, Gladys. Twice a trailblazer, McNatt also was Teaneck's first African American municipal judge. (Courtesy of the *Record of Hackensack*.)

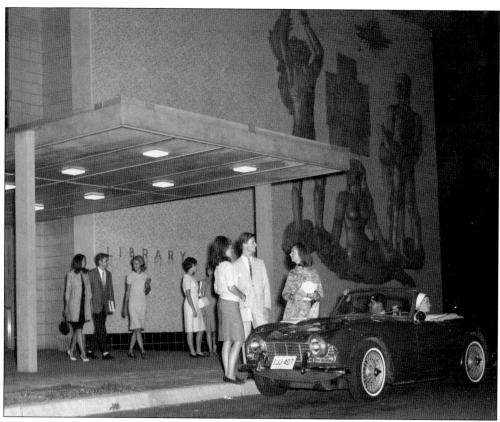

Smartly attired Fairleigh Dickinson University (FDU) students, above, come and go at the library on the Teaneck campus in 1966. Below, Texas senator Lyndon B. Johnson, wearing a white hat and clutching an FDU pennant, stumped for vice president on campus in 1960. Johnson, on the Democratic ticket with John F. Kennedy, is seen shaking hands with Dr. Peter Sammartino, the school's founder. Today, FDU is New Jersey's largest private college; its Metropolitan Campus spans the Hackensack River in both Teaneck and Hackensack. (Both, courtesy of Fairleigh Dickinson University.)

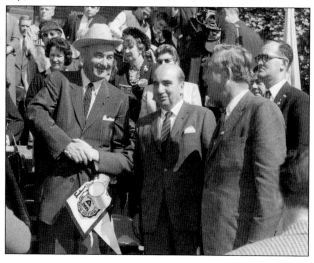

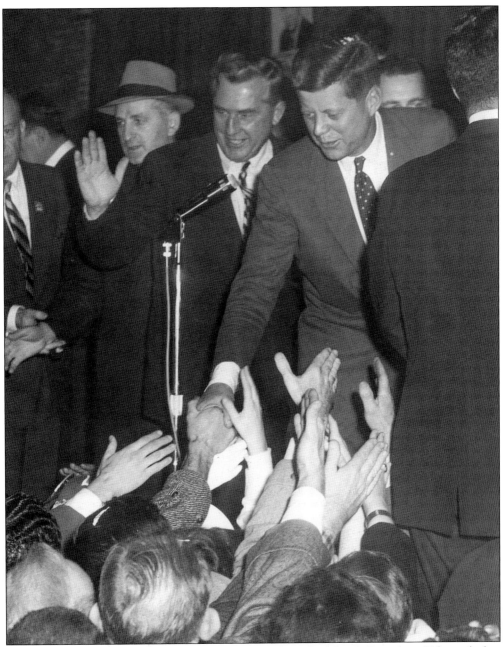

John F. Kennedy's road to the White House wound through Teaneck. Less than 48 hours before Americans headed to the polls in 1960, the Democratic senator from Massachusetts swung through New Jersey, including a frenzied rally at the Teaneck Armory, where 14,000 people waited more than three hours for his arrival. Here, Kennedy pressed the flesh from the stage, while New Jersey governor Robert B. Meyner stood to his right. "I'm sorry I'm late," Kennedy quipped when he got to Teaneck, "but I haven't been playing golf." Kennedy carried New Jersey by just 22,000 votes in defeating his Republican rival, Richard Nixon. (Courtesy of the *Record of Hackensack*.)

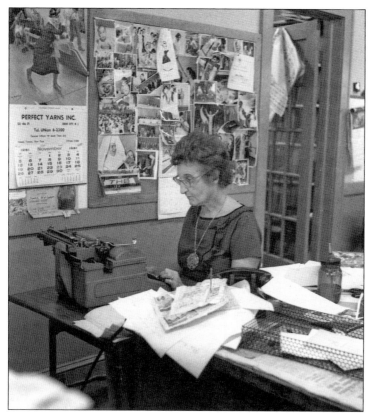

Mildred Taylor reported for newspapers in Illinois, Texas, and California before finding her calling as women's editor of the weekly *Teaneck Sunday Sun*, where she is pictured at left at her typewriter. The Palisade Avenue resident reveled in her role as local historian. Her book *The History of Teaneck* was published in 1977 after 20 years of research. Below, she autographed copies of *The History of Teaneck* at the public library. Emmett Francois, who took these photographs, worked with Taylor at the *Sunday Sun*. (Both, courtesy of the Teaneck Public Library.)

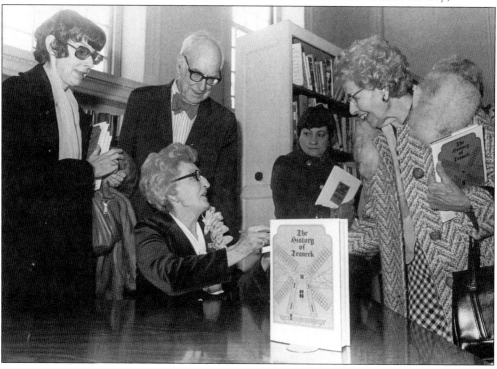

This early-1960s view of Cedar Lane, at Palisade Avenue, shows two now-gone landmarks: Teaneck's great red oak, at left, and the Teaneck Grill diner, at right. The tree, 85 feet tall and with a trunk circumference of 18.5 feet, was one of the largest oaks in New Jersey. Decay and termite damage led to its removal in 2013. It was estimated to be 300 years old. (Photograph by Emmett Francois; courtesy of Judith Distler.)

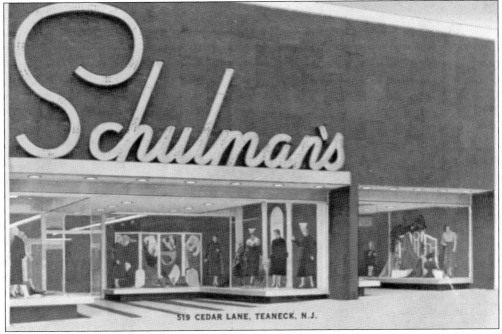

519 CEDAR LANE, TEANECK, N.J.

With its showy neon sign, attentive customer service, and half-priced swimsuit sales, Schulman's on Cedar Lane was the place to go for quality women's clothing. Herman and Lois Schulman opened the shop in 1951 and ran it for half a century. (Courtesy of the Berdan collection.)

BRYANT SCHOOL

Grade 6-1

1966 1967

114

The school integration plan put into effect in September 1964 and affirmed by Teaneck voters in February 1965 involved converting Bryant School, located in the increasingly African American northeast sector, to a central sixth grade. All Teaneck sixth grade students were assigned to Bryant, and kindergartners through fifth graders in the Bryant district were assigned to other township elementary schools, with the realignment achieved through busing. This 1966–1967 Bryant School class picture reflects the intended effect of the integration effort. (Courtesy of David Fox.)

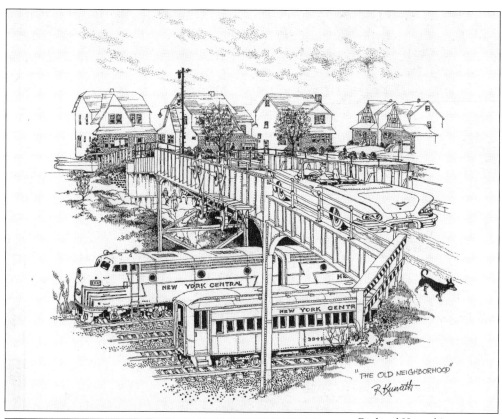

"THE OLD NEIGHBORHOOD"
R.Kunath

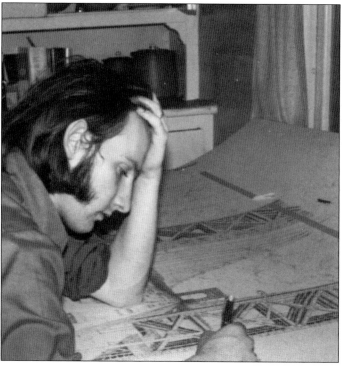

Richard Kunath's pen-and-ink drawings captured the essence of Teaneck. Kunath, a graduate of the Newark School of Fine and Industrial Arts, ran a commercial sign-painting company on Cedar Lane and was responsible for the original "Welcome to Teaneck" road signs. The above drawing, of commuter trains passing under the Grayson Place bridge, is a scene from Kunath's boyhood on Windsor Road, parallel to the train tracks. At left, the young artist worked at his drawing table. The lifelong Teaneck resident died of cancer in 1998 at age 51, but his creative legacy endures. (Both, courtesy of Cecilia Kunath.)

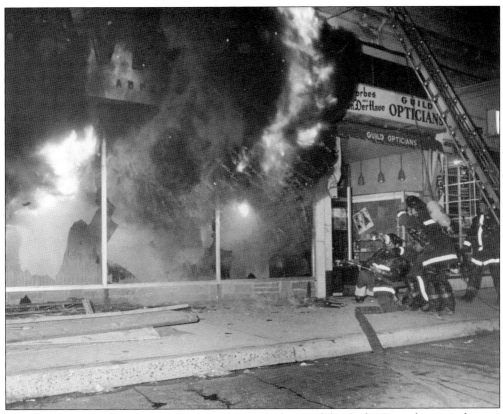

This May 26, 1972, fire destroyed three stores in the heart of the Cedar Lane shopping district. Chlorine fumes from the Davis swimming pool supply store complicated firefighters' efforts. (Photograph by Emmett Francois; courtesy of the Teaneck Public Library.)

The Ronald Furniture Company store, at Teaneck Road and Cedar Lane, lost much of its merchandise in this August 11, 1971, fire. (Courtesy of Robert Montgomery.)

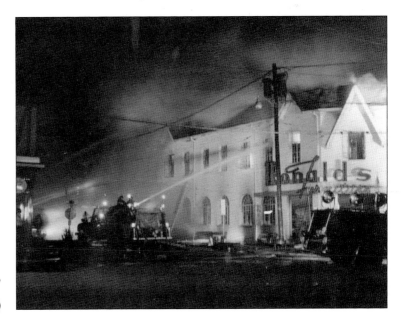

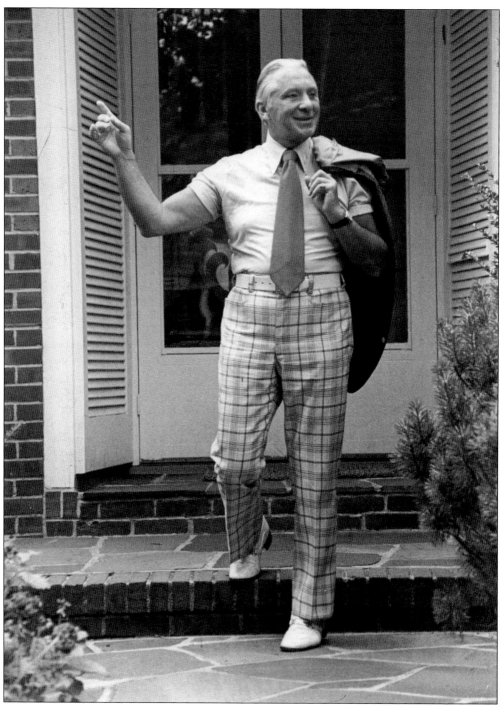

Matthew Feldman, Teaneck's first Jewish mayor, helped coalesce the township's religious and racial communities around school integration. After moving on to the state senate, the silver-haired Democrat was instrumental in crafting policy on the environment, education, and civil rights. A wooded area in northwest Teaneck was named the Matthew Feldman Nature Preserve in 1989. (Courtesy of the Teaneck Public Library.)

Eleanor Kieliszek, pictured at a 1978 event marking the start of UA Columbia cable television service, was Teaneck's first woman mayor, serving from 1974 to 1978 and 1990 to 1992. Her membership in the League of Women Voters was a springboard to a productive three decades in public life. (Courtesy of the Teaneck Public Library.)

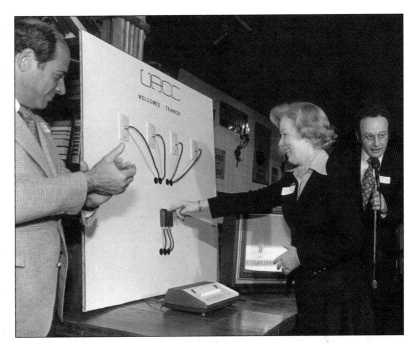

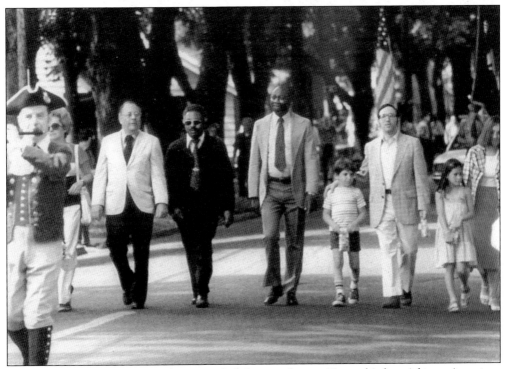

Bernard Brooks, at center marching in a holiday parade, was Teaneck's first African American mayor, in office from 1982 to 1988. A financial and management consultant, Brooks applied his professional skills to his township duties and helped usher local government into the computer age. The man in the white jacket, Francis "Frank" Hall, was both Brooks's predecessor and successor. Hall served as mayor from 1978 to 1982 and 1988 to 1990. (Courtesy of Bill Hall.)

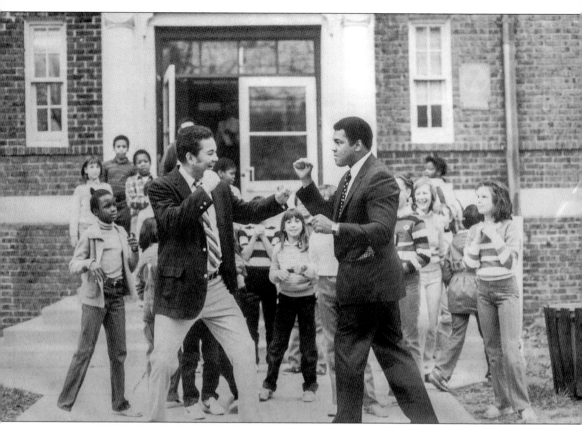

It is not often that the world's most famous athlete drops by, but in the 1980s, that was old hat at Whittier School. Miya Ali, a daughter of Muhammad Ali, lived in Teaneck and attended Whittier, which meant "the Greatest" was no stranger. Ali, recently retired from the boxing ring, playfully squared off against principal Alfred Mitchell during this visit. (Photograph by Judith Distler; courtesy of Whittier School.)

Civil rights icon Rosa Parks toured Teaneck in 1983 during a whirlwind day organized by township resident and schoolteacher Theodora Lacey. Here, Parks received flowers from children at Bryant School. Lacey knew Parks from their hometown of Montgomery, Alabama—Parks was a family friend, and young Theodora participated in the bus boycott Parks precipitated. Lacey, who with her husband, Archie, pushed for the integration of Teaneck schools, recalled in 2019 that Parks was "overwhelmed with joy" by her visit to Teaneck because "the children just wanted to be close to her." A commemorative button was made for the occasion. (Both, courtesy of Theodora Lacey.)

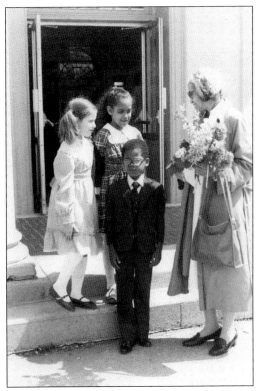

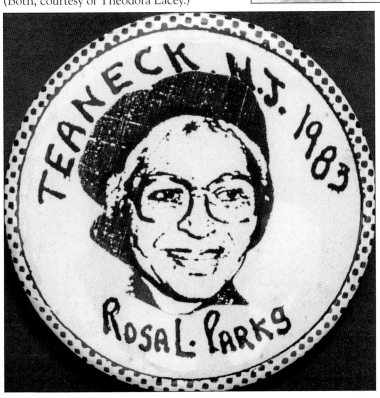

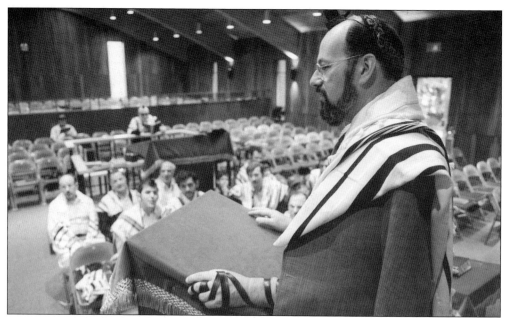

Congregation Bnai Yeshurun, Teaneck's first Orthodox Jewish synagogue, was founded by a handful of families in 1958. After a year of worshiping in the basement of a home on Downing Street, the families purchased a small house at 641 West Englewood Avenue and altered it sufficiently so services could be held there. A decade later, the growing congregation built a new synagogue on that spot. Here, Rabbi Macy Gordon leads prayers in the sanctuary in 1975. (Courtesy of the *Record of Hackensack*.)

Bergen County's first mosque opened in 1986 in Teaneck. The Dar-Ul-Islah congregation purchased property on Fabry Terrace, in the Glenwood Park neighborhood, seven years earlier, raising the required funds through contributions. Here, Muslim community members gathered at the future site of the mosque for prayers under a tent. (Courtesy of Shahanaz Arjumand.)

In 1969, Councilman and future mayor Frank Burr proposed redevelopment of a marshy tract near Interstate 95, seen in the aerial photograph at right, as a way of easing the property tax burden on homeowners. A commercial and townhouse complex called Glenpointe took shape over two decades, its planning overseen by an appointed redevelopment agency. The postcard below shows the project's most prominent component, a 14-story hotel, which opened in 1983. That hotel is now a Marriott; Glenpointe gained a second hotel tower in 2018. (Right, courtesy of the *Record of Hackensack*; below, courtesy of the Teaneck Public Library.)

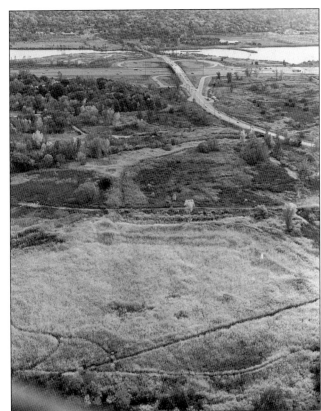

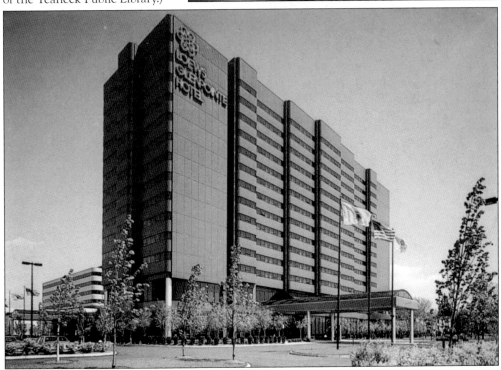

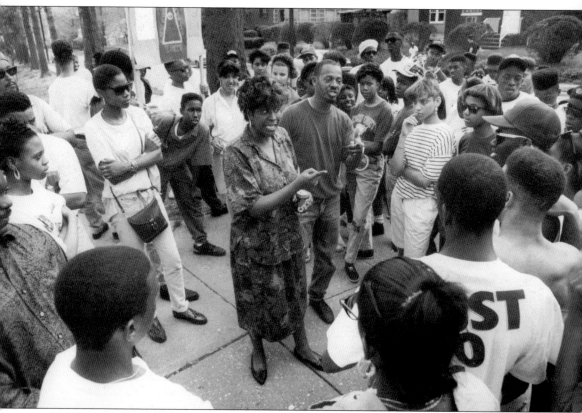

The fatal shooting of a fleeing black teenager by a white police officer on April 10, 1990, sparked violence and demonstrations and thrust Teaneck—known for its diversity and history of racial progress—into a harsh spotlight. Thelma Pannell, mother of the slain teenager, Phillip Pannell, spoke with youths at Tryon Park two weeks after the shooting, imploring them to remain calm and repudiate violence. The officer, Gary Spath, was acquitted of manslaughter in 1992, the verdict closing a wrenching chapter in Teaneck's history. (Courtesy of the *Record of Hackensack*.)

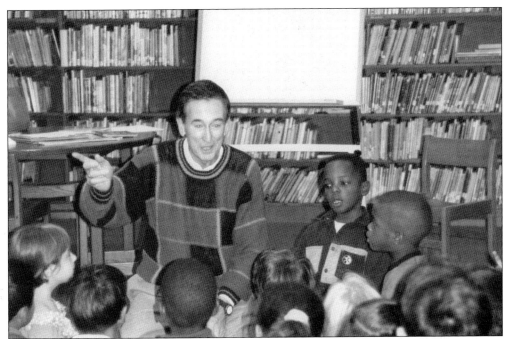

Generations knew music teacher Bob Johnson as a resident of *Sesame Street*. Bob McGrath, the actor who played that role on the long-running children's television series, resided for decades in Teaneck. Like his character, McGrath was a beloved community member. Whether performing with children at the farmers' market or promoting reading during classroom visits, like this one at Hawthorne School, McGrath was a friend to all. (Courtesy of Judith Distler.)

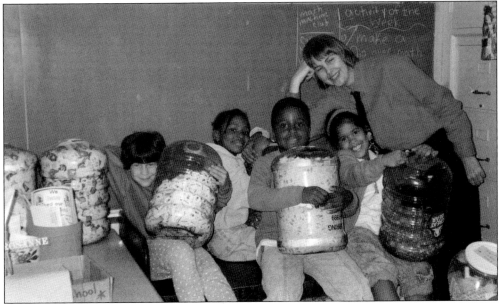

When a student asked Rosanne Ponchick in 1980 what the number one million looked like, the Teaneck elementary schoolteacher had an idea: Why not collect and count the tags from tea bags—tea, as in "Tea"-neck? In 1992, Ponchick and her Whittier School students showed off some of the four million tea tags they had collected up to that point. (Courtesy of Rosanne Ponchick.)

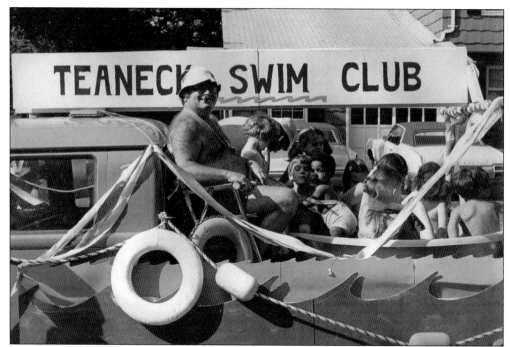

Murray Firestone led the drive to develop a privately run municipal pool on township-owned land near the Hackensack River. Here, the cigar-smoking Firestone and a group of children cruised town in the bed of a panel truck to promote membership in the Teaneck Swim Club, which opened in 1977. (Courtesy of the Teaneck Swim Club.)

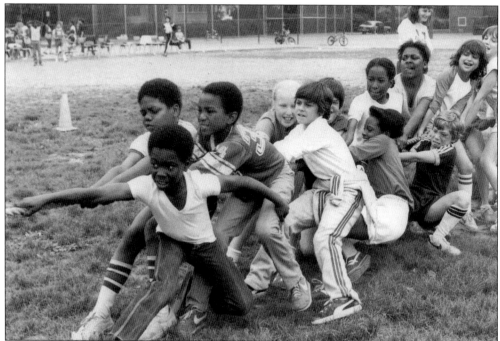

Children enjoy a spirited game of tug-of-war at Whittier School, a scene emblematic of Teaneck—the town that pulls together. (Courtesy of Judith Distler.)

INDEX

Discover Thousands of Local History Books Featuring Millions of Vintage Images

Arcadia Publishing, the leading local history publisher in the United States, is committed to making history accessible and meaningful through publishing books that celebrate and preserve the heritage of America's people and places.

Find more books like this at
www.arcadiapublishing.com

Search for your hometown history, your old stomping grounds, and even your favorite sports team.